IMAGES
of America

GARDEN
OF THE GODS

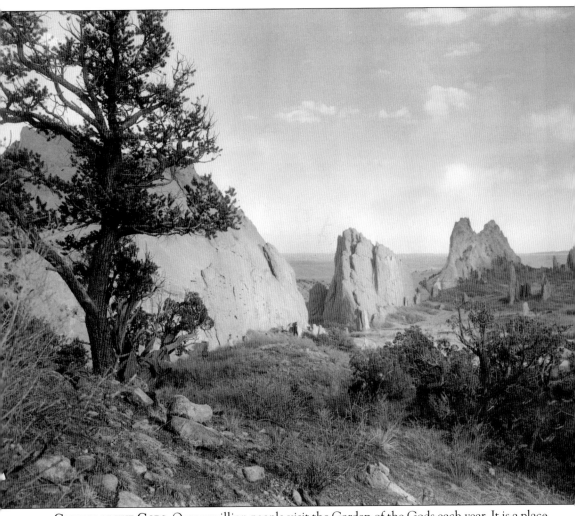

GARDEN OF THE GODS. Over a million people visit the Garden of the Gods each year. It is a place of spiritual significance for some, a place to study nature for many, and an inspiration for works of literature and art for others. (Colorado College Tutt Library Special Collections, Standley.)

ON THE COVER: BALANCED ROCK. The most popular place to be photographed in the Garden of the Gods, Balanced Rock was privately owned by the Goerke family until 1932. (Old Colorado City Historical Society.)

IMAGES
of America

GARDEN
OF THE GODS

Toni Hamill and the
Manitou Springs Heritage Center

ARCADIA
PUBLISHING

Published by Arcadia Publishing
Charleston, South Carolina

Printed in the United States of America

Library of Congress Control Number: 2011940756

For all general information, please contact Arcadia Publishing:
Telephone 843-853-2070
Fax 843-853-0044
E-mail sales@arcadiapublishing.com
For customer service and orders:
Toll-Free 1-888-313-2665

Visit us on the Internet at www.arcadiapublishing.com

To my mother, Barbara Weber, who would have been so proud

CONTENTS

ACKNOWLEDGMENTS

The Garden of the Gods has captivated me ever since my first day of Archaeological Field School with the University of Colorado, Colorado Springs (UCCS) under the direction of Dr. Thomas Wynn. Without Tom's willingness to allow an "older" student to participate in his physically demanding course, this book would never have happened. Many people have helped me along the way. My husband, Bill, has challenged me to be organized and has been a great help. My son and daughter-in-law connected me with Kim Evans, who took the beautiful contemporary photographs. The Manitou Springs Heritage Center (MSHC), my partners in this venture, and Deborah Harrison provided many images from their collection. Don Kallaus, of the Old Colorado City Historical Society (OCCHS); Seyhan Tahire Dwelis and Bill Arbogast, of University of Colorado, Colorado Springs (UCCS); Amy Brooks, of the Colorado College Tutt Library Special Collections (CC); and the archivists at the Colorado Springs Pioneers Museum (CSPM) were very helpful in finding images for me. Other sources of images were the Pikes Peak Library Special Collections (PPLD), the Western History/Genealogy Department of the Denver Public Library (DPL), and the Colorado Historical Society (CHS). Thank you also to my editors at Arcadia, Debbie Seracini and Stacia Bannerman, for their help guiding me through this project. Courtesy lines for the sourcing of photographs are designated by the abbreviations shown above in parenthesis, followed by photographers names when available. Photographs from the author's collection are designated AC.

The source for historical information is my master of arts thesis, *People of the Garden* (published in 1997), as approved by Dr. Thomas Wynn, Dr. John Miller, and Dr. Linda Watts to whom I am indebted for their guidance and support.

INTRODUCTION

The Garden of the Gods in Colorado Springs, Colorado, is an unusual area of dramatic red rock formations created over the span of millions of years. Cycles of geologic upheavals followed by erosion built and destroyed two ranges of ancient Rocky Mountains. More cycles of climate change, from desert to tropical, and the advancing and retreating of a shallow sea resulted in different layers of deposits, including remains of sea creatures and ancient plant and animal life, which compacted and cemented into rock. A final upheaval along natural fault lines created today's Rocky Mountains, the spectacular rock formations of the Garden of the Gods, and the mineral springs in nearby Manitou Springs.

On the line where the Great Plains meet the Rockies, the Garden of the Gods, Glen Eyrie, and Red Rock Canyon are where three of the largest natural ecological zones most distinctly meet. Each of these eco-niches includes not only plants, but also many animals dependent upon those plants for food. Ancient peoples who used the rock overhangs in the Garden of the Gods for shelter from the elements were probably first attracted to this mystical place by the variety and abundance of animal and plant life.

Archeologists have determined that for more than 11,000 years, several different groups of prehistoric peoples who were hunters and gatherers or part-time horticulturists made the Front Range of the Rockies their home. Evidence found in the Garden of the Gods in 1993 indicates a presence of people in approximately 1330 BC, and a radiocarbon dating in 1996 indicates seasonal encampments by around 250 BC.

The Ute, Apache, Kiowa, Shoshone, Comanche, Cheyenne, Arapaho, Pawnee, and Lakota Nations all claim a connection to the Garden of the Gods. However, the Utes, who have a longer continuous history in Colorado than any other tribe, have the strongest claim. Through their oral traditions, Ute Indians claim their connection to the Garden of the Gods from their creation. Ancient rock art in the form of petroglyphs typical of early Utes has been found in the Garden of the Gods.

The Garden of the Gods was a traditional winter and sometimes summer campground for the Utes, who camped along Camp Creek by Rock Ledge Ranch and near Manitou Springs because the area among the red rocks is spiritually important to them. After other Indians moved into the plains, the area of Colorado Springs was shared by the Utes and other tribes. Because the Utes usually spent their summers in the South Park area, the other tribes would travel through the Garden of the Gods on their way up Ute Pass to South Park to raid the Utes and try to steal their horses.

During the 16th century, the pinnacles and spires of the Garden of the Gods witnessed the gradual development of another type of human interaction. Beginning in 1535, Spain claimed a stretch of country east of the Rocky Mountains extending from Mexico north to the Yellowstone River in present-day Montana. During this period of Spanish ownership, a number of expeditions explored the region from Santa Fe, New Mexico, to the Platte River in Colorado looking for Cibola,

the fabled city of gold. The earliest recorded Spanish expedition to the Pikes Peak area was in 1598. Juan de Onate, a relative of Cortez and Montezuma, attempted a large expedition into the northern country. A short time later, he sent his nephew Juan de Zaldivar with a company of cavaliers farther into the interior. Zaldivar progressed along the foothills nearly to where Denver is today. Any explorers who came through the area of the present Colorado Springs would have seen the Garden of the Gods and very likely went through it on their way up Ute Pass or to visit the mineral springs.

French trappers from Canada drifted through the area during the 18th and early 19th centuries, penetrating Ute Pass to South Park's lush grasslands. They left their traces on the rocks in the Garden of the Gods and in place names around Pikes Peak. The Fountain Creek was first called the Fontaine qui Bouille, or the "fountain that boils," because of its turbulence and because of the bubbling springs in the vicinity.

In 1820, Maj. S.H. Long's expedition secured the services of Frenchmen Joseph Bijeau and Abraham Ledoux to act as guides. They crossed Palmer Divide and followed Monument Creek south, intending to climb the great peak and determine its altitude. Major Long named it James Peak in honor of Dr. Edwin James who is reportedly the first white man to ascend it. After about 1840, this name was gradually dropped, and Pikes Peak was substituted in honor of Zebulon Pike. Bijeau told the party about the boiling springs on the Fontaine qui Bouille and guided some of the men to them. At the springs, they discovered ornaments of beads, shells, and so on that wandering bands of Indians had cast into the springs as offerings to the Great Spirit. The members of this expedition also commented on a "large and frequented road" that passed the springs westward into the mountains. This road was the old Ute Trail through the Garden of the Gods and up Ute Pass.

In 1833, Ceran St. Vrain and William and Charles Bent opened the Bent's Fort trading post on the Arkansas River, giving the mountain men a place to swap their beaver pelts for supplies. This had the effect of opening up the fur trade in the Colorado Rockies, which brought more trappers and traders through Ute Pass and into contact with the Garden of the Gods area. Along with Dick Wooton and William Kroenig, Joe Doyle, a trapper who worked for Bent and St. Vrain Co., owned the Soda Springs on the Fontaine qui Boille in 1859. They planned to develop the springs into a spa they called the Saratoga of the West.

During the summer of 1843 and with Kit Carson as guide, Lt. John C. Fremont went from the mouth of the Fountain northward along the stream to the springs of Manitou. He and James Hall, a paleontologist traveling with him, described the trip and the Garden of the Gods in their journals. In 1847, British explorer Lt. George Frederick Ruxton visited the Garden of the Gods and the Fontaine qui Bouille. In the early spring, Ruxton went up the Fontaine qui Bouille to hunt and to pasture his animals in the mountains. In his journal, he too describes the Garden of the Gods.

After the discovery of gold in 1859, the cry, "Pikes Peak or Bust," drew the hopeful to the Pikes Peak region and the Garden of the Gods. The era of gold-seekers, settlers, and entrepreneurs began. Those who passed through the garden left their marks. Some 118 names were carved into the rocks between 1731 and 1890, many of them in a great cave in the North Gateway Rock. More than 30 of the carvers have been identified. Carving names in the rocks was a tradition that continued until the Garden of the Gods became a city park. Now, carving anything into the rocks is forbidden to protect the historic names and dates and to protect the rocks themselves.

In 1859, Melancthon S. Beach, a member of the Lawrence party of gold-seekers, organized the Colorado City Town Company. He and Rufus E. Cable rode down from Denver on horseback and staked out Colorado City on August 14. Inspired by the red rocks, they used *Colorado*, the Spanish word for "red," as the name. Prior to 1859, the Garden of the Gods had been called the Red Rock Corral. According to Irving Howbert and M.S. Beach, inspired by its beauty, Rufus Cable gave the Garden of the Gods its name.

Visitors to Colorado City wrote vivid descriptions of the rock formations to friends and family. These fanciful descriptions and the attraction of gold drew more people to the area. In

1861, Colorado became a territory, with Colorado City as the first capital. More people required better transportation and services. The trail up Ute Pass was widened into a road. Enterprising businessmen opened establishments to accommodate the influx of people, and the Indians became aggressive in their attempts to protect their way of life.

In 1862, Irving Howbert's family bought a ranch on Camp Creek just above Colorado City. Their land extended north to Glen Eyrie, and they ran cattle on the vacant land around the Garden of the Gods and west of the valley of Camp Creek. They did not make a claim on the Garden of the Gods because they thought it of little worth. A number of other people did lay claim to the Garden of the Gods, but none stayed because of the lack of water. Finally, in 1874, Robert Chambers bought the claim for $1,400, built a stone house, dug a reservoir for irrigation, and planted an orchard.

The springs at Manitou underwent several changes of ownership as well. Dick Wooton sold the springs in 1859 for $500. The claim was sold or jumped more than seven times until Gen. William Jackson Palmer's Colorado Springs Company bought the springs for $26,000. The company then founded the resort town of LaFont, which later changed to the name Manitou. General Palmer chose Glen Eyrie for his home because of the absence of water in the Garden of the Gods. However, Palmer loved the Garden of the Gods, so he convinced his friend Charles Perkins to buy it. Perkins purchased 480 acres in and around the Garden of the Gods in 1879 for $10,473.

The area outside of Perkins's holding was vulnerable to development, such as a gypsum quarry, a lager saloon, and a stairway to the top of Gateway Rock. In 1898, the Garden City development was platted a block or so east of the Gateway Rock where Fatty Rice established an emporium to sell "strong" refreshments, food, and curios. Palmer and Perkins objected to this distraction from the beauty of the surroundings, so Palmer purchased the Garden City lots, the Chambers Ranch, and Fatty's property as a buffer zone for the Garden of the Gods. After Palmer's death, this land was incorporated into the city park system and is now the Rock Ledge Ranch Historic Site.

In 1909, Charles Perkins's family gave the Garden of the Gods to the city of Colorado Springs as a free public park in accordance with his last wishes. Since that time, the city has purchased land around the park until it has reached 1,364 acres. Long-standing encroachments, like the Goerke's photography business with a fence surrounding Balanced Rock and Steamboat Rock, have been torn down and the rock formations returned to a natural state. The Hidden Inn site and most of the roads and trails have also been returned to a natural state. The Garden of the Gods Visitor and Nature Center, which opened in 1995, was built just outside the park and serves as a starting point for visits to this spectacular attraction.

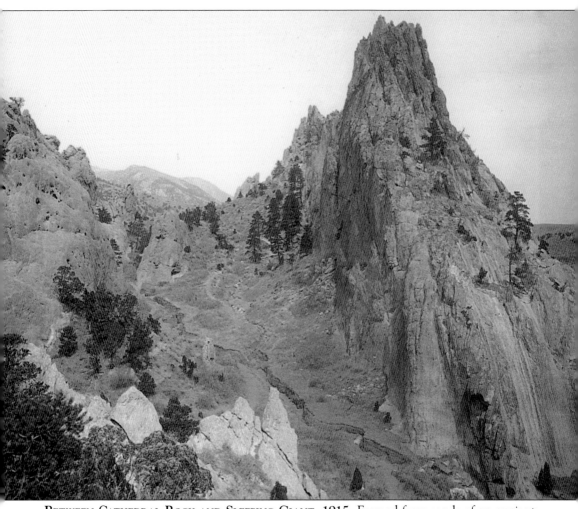

BETWEEN CATHEDRAL ROCK AND SLEEPING GIANT, 1915. Formed from sands of an ancient, 280-to-245-million-year-old beach, Cathedral Rock has no fossils and is an example of the Lyons formation. (CSPM.)

One

GEOLOGIC FORMATION
FROZEN INVADERS AND DINOSAURS

Millions of years ago, an inland sea covered Colorado. Pressure beneath the earth's surface pushed up massive blocks of rock, forming the Ancestral Rocky Mountains. Small streams eroded the mountains. Streams widened into rivers washing sand, gravel, and mud into the sea. Debris settled to the bottom and compacted into sedimentary rock thousands of feet thick. Minerals flowed into the sediment creating the deep-red Pennsylvanian and the pinker Permian layers.

The Ancient Rockies gradually disappeared, and the sea withdrew. Sand dunes creating white to red Lyons Sandstone remained where the sea had withdrawn. The climate changed, and moist, tropical air warmed Colorado. Freshwater streams flowed into lakes and swamps. In the humid lowland climate, Stegosaurus grazed the land. Fish-like reptiles, crocodiles, ammonites, sharks, and rays inhabited the lakes and lagoons.

A hundred million years passed. A shallow Cretaceous sea spread from the Arctic to the Gulf of Mexico. Large marine lizards swam in the sea and crawled on the bottom. On the shore, Iguanodons browsed on primitive flowering plants.

The Cretaceous sea slowly withdrew and left the gray mud of Pierre Shale behind. Mountains began to form, raising the buried Fountain and Lyons formations and other sedimentary rocks to vertical positions. As the mountains rose, the basins sank. Rivers and streams carved into the hills, filling the valleys with gravel, sand, and silt. Pressure built until the area from mid-Kansas to the deserts of Utah lifted, rising 5,000 feet above sea level. Erosion near the mountains created a broad valley between the High Plains and the Rocky Mountains. Streams along the mountains changed course and began to flow northward and southward. The mountains again eroded away.

Finally, a third set of Rocky Mountains was formed by uplift at the faults and volcanic activity. This raised the Pikes Peak region to its present elevation. The earth grew colder, ushering in the Pleistocene Ice Age. Glaciation and erosion carved the rocks of the Fountain and Lyons formations and created the spectacular towers, pinnacles, and mushroom-shaped rocks of the Garden of the Gods.

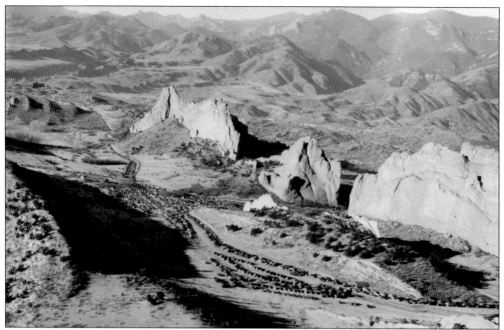

RAMPART RANGE FAULT. The Cretaceous sea withdrew leaving shale and sand behind 75 million years ago. Mountains began to form, raising the colorful rock formations of the Garden of the Gods, Red Rock Canyon, and Glen Eyrie to vertical positions between the Rampart Range Fault and the Ute Pass Fault. (CC.)

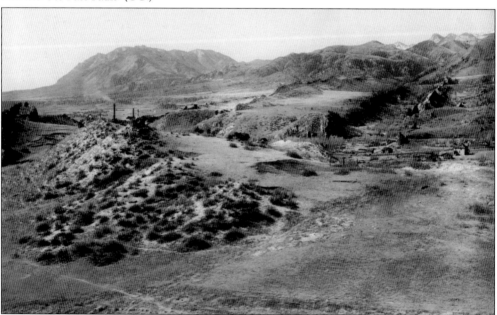

MOUNTAINS RISE, BASINS SINK. For 20 million years, swift rivers and streams carved into the hills filling valleys with gravel, sand, and silt. Erosion wore away several thousand feet of sediments deposited in the basins, leaving a broad valley between the High Plains and the Rocky Mountains. Streams along the mountains changed course to flow northward and southward, stripping away what was left of the High Plains. (CC.)

12

RED ROCK CANYON. The earth grew colder, ushering in the Pleistocene Ice Age three million years ago. The accompanying glaciation eroded the high country and the Colorado Piedmont. (PPLD, Myron Wood.)

TOWERS AND PINNACLES. Erosion carved the rocks of the Fountain and Lyons formations bent up by the mountain uplift and created the spectacular towers, pinnacles, and mushroom-shaped rocks of the Garden of the Gods. (MSHC, Irwin.)

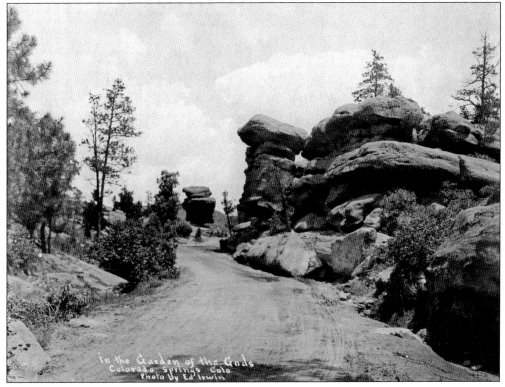

13

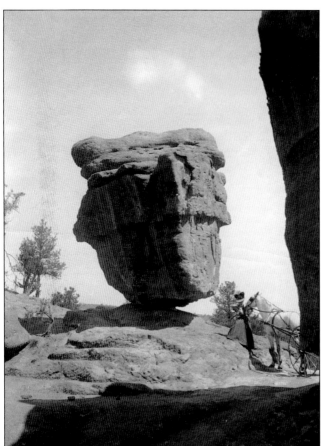

BALANCED ROCK. A good example of the Fountain formation named for the nearby Fountain Creek, Balanced Rock gets its red color from the mineral hematite, which, along with silica, bonds the coarse sands and gravels together. (OCCHS.)

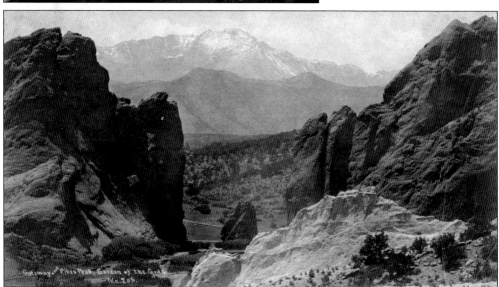

WHITE ROCK. The lighter-colored Lyons formation is made of fine-grained sand. White Rock (in the foreground) and the Tower of Babel, which seem to have been formed from the sands of an ancient beach but lack fossils, are from the Lyons formation. (MSHC, Clinton.)

SLANTED ROCKS. The various rock features in the Garden of the Gods area have five different classifications—slanted, toppled, stood-up, pushed around, and overturned—depending on which fault or forces of nature acted upon them. The slanted rocks, varying in the degree of their slants, were bent upward by tremendous forces along the faults and uncovered by erosion, which also gave the rocks their present shapes. (CC.)

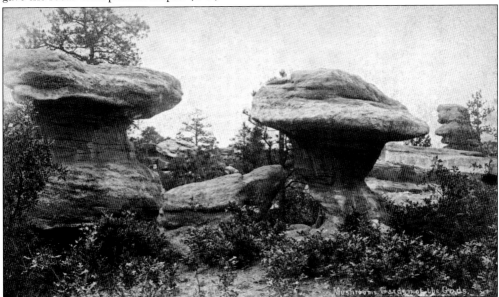

TOPPLED ROCKS. The toppled rocks have fallen from projecting ledges through wind and erosion. Each settled at its own new tilt, some even upside down. Balanced Rock and Toad and Toadstools originated this way. Their weight compacted the soil underneath, and their bulk protected them from weathering. When the surrounding soil was washed or blown away, the toppled rock was left on a pedestal. (MSHC, Hook.)

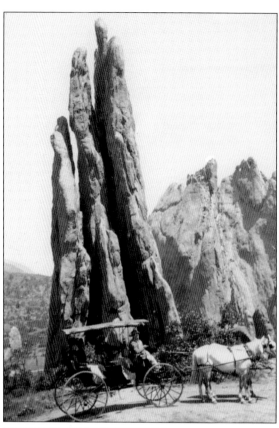

STOOD-UP ROCKS. The Three Graces and the Gateway Rocks are examples of stood-up rocks. A great upward force broke the rocks along the Rampart Fault and turned them to a vertical position. (CC.)

PUSHED-AROUND ROCKS. The pushed-around rocks seen just east of Sleeping Giant became stood-up rocks near the Lyons Fault (parallel to and just west of Sleeping Giant) before they were caught in the movement of that fault and turned until they pointed nearly southwest. (CC.)

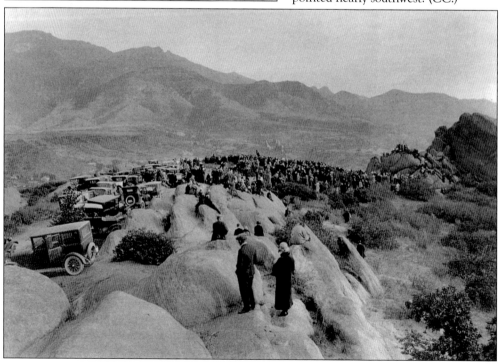

OVER-TURNED ROCKS. The over-turned rocks seen in the Tower of Babel were turned beyond the vertical position until the older layers were somewhat above the younger ones. (CSPM.)

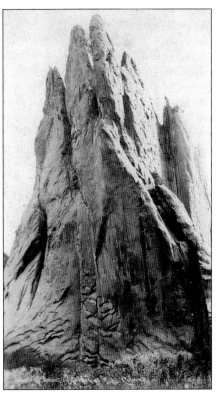

MINERAL SPRINGS. Springs of mineral water bubble to the surface through a number of channels in the shattered rock along Ute Pass Fault. The water is naturally carbonated with carbon dioxide from carbonate rock (Paleozoic limestone) at a depth where pressure is similar to that in a capped soda bottle. The bubbling springs contribute water to Fountain Creek, which was formerly named Fontaine qui Bouille, meaning "fountain that boils." (MSHC, Brant.)

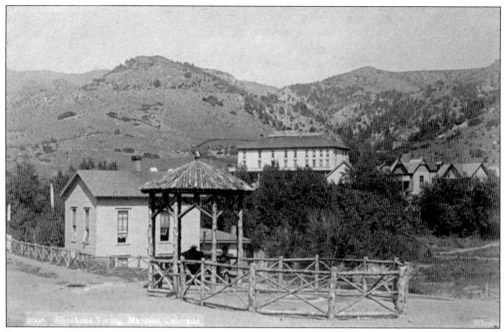

SHOSHONE. In his book *The Crest of the Continent*, Ernest Ingersoll speaks of six springs varying in temperature from 43 degrees to 56 degrees Fahrenheit, "all strongly charged with carbolic acid." The first spring he writes of is the Shoshone close to the main road, also called the Sulfur Spring from the yellow deposit around it. (MSHC, Stormer.)

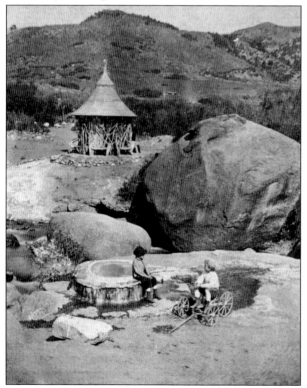

NAVAJO. A few yards farther on and in a ledge of rock overhanging the right bank of the Fountain is the Navajo, which contains carbonates of soda, lime, and magnesia and is more strongly charged with carbolic acid than the Shoshone. The Navajo has a refreshing taste similar to seltzer water. (MSHC, Brant.)

MANITOU SODA SPRING WATER CARRIERS. Across the stream from the Navajo is the Manitou. Its taste and properties resemble the Navajo. (MSHC, Chamberlain.)

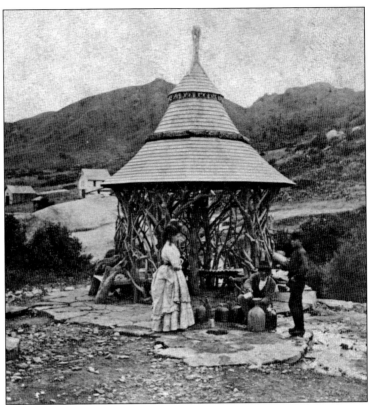

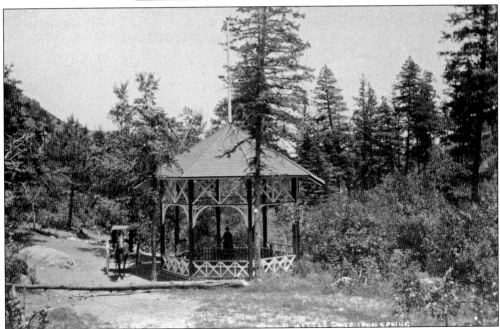

UTE CHIEF. Up Ute Pass about a quarter mile on the right bank of the Fountain is the Ute Soda (now the Ute Chief Spring), which resembles the Manitou and Navajo springs but is chemically less powerful and very refreshing. (MSHC.)

IRON UTE. On Ruxton Creek is the Iron Ute Spring. This water is effervescent, cool at 44.3 degrees Fahrenheit, and said to be agreeable despite its strong taste of iron. (Brant, MSHC.)

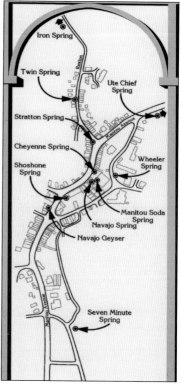

MAP OF MINERAL SPRINGS, 2009. The Manitou Springs Visitors Bureau reports the location of four more springs: the Twin Spring on the left side of Ruxton Avenue past Osage Avenue, Stratton Spring at the corner of Ruxton and Manitou Avenues, Wheeler Spring on the left side of Canon Avenue north of Park Avenue, and Seven Minute Spring off El Paso Boulevard north of Mansions Park. (MSHC.)

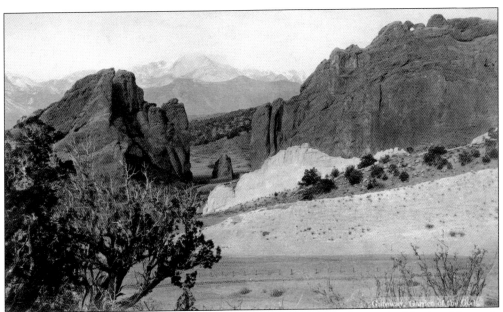

GATEWAY, GARDEN OF THE GODS. The Garden of the Gods area with its colorful mix of dramatic rocks as the centerpiece has attracted people and animals because of its physical location at an important geographical, biological, and ecological convergence. To the east is the prairie, to the southwest is arid foothill and canyon country, and to the west and northwest are the rugged higher mountains. (MSHC, Hook.)

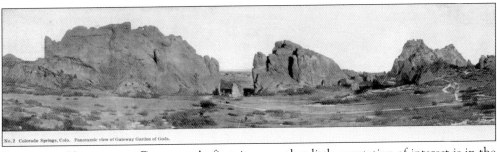

PANORAMIC VIEW OF THE GATEWAY. At first, it seems that little vegetation of interest is in the Garden of the Gods; however, it is a center of unusual plant and animal associations. The three great plant associations, or zones—the Upper Sonoran (Pinon-Juniper Woodlands), the Transition (Ponderosa Pine Woodlands), and the Brushland (Scrub Oak and Mountain Mahogany)—very distinctly meet in the Garden of the Gods area. (CC.)

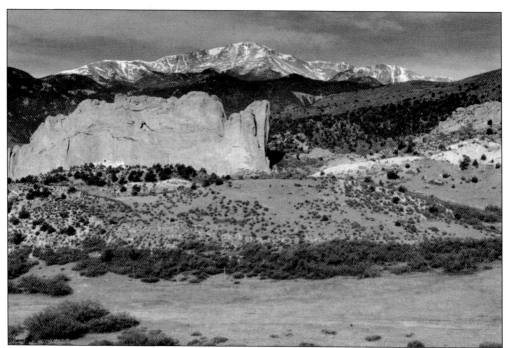

KISSING CAMELS AND PIKES PEAK. Upper Sonoran Pinon-Juniper Woodlands extend from south-facing slopes two miles north of Queens Canyon at Glen Eyrie southward and westward around the foot of the mountains into New Mexico, Utah, and Arizona. The transition zone of Ponderosa pine, Douglas fir, and Colorado blue spruce forests may be seen on the western and northern borders of the Garden of the Gods and Glen Eyrie. (CC, Beidleman.)

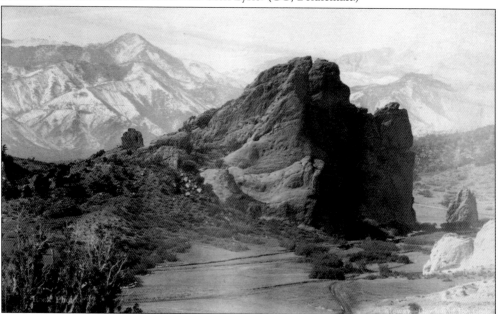

SOUTH GATEWAY AND PIKES PEAK. In this 1895 photograph, the Brushland zone is visible, typified by scrub oak and mountain mahogany in the foothills north and west of the Upper Sonoran zone and on north-facing slopes in the Garden of the Gods below the Transition zone. (CC.)

Two

PREHISTORIC CULTURES
HUNTERS AND GATHERS
AND EARLY UTES

Evidence found in 1993 indicates people were in the Garden of the Gods as early as 1330 BC. Bifacial stone scrapers, chert flakes, fire-cracked rocks, grinding stones, and a shard of pottery were found while excavating several hearths and a rock shelter in July 1996. According to radiocarbon dating, seasonal encampments were in the Garden of the Gods by around 250 BC. Because of the lack of charred animal bones or any evidence of long-term occupation, the individual hearths were likely used in spiritual rituals. The peoples using these encampments were of the middle to late Archaic period (3,000 BC–AD 500) and of the early Ceramic/Woodland period (AD 1–AD 1,000).

The people of these periods were differentiated primarily by the additional skills of pottery making and the cultivation of corn. These hunter-gatherers camped under rock overhangs. Moving with the seasons to follow game, they hunted small- and big-game animals and foraged for vegetables and grain to collect enough food for immediate needs and for winter storage. They developed tools, like the atlatl, mulling stones, basketry, rabbit nets, stone drills, scrapers, and bone awls. They used heated stones for warming food in skin or fiber bags and as a source of heat for small shelters.

These hunter-gatherers developed semipermanent settlements of less than 25 people at locations with water, good vantage points, and that were rich animal and plant life, all of which are available in and around the Garden of the Gods. They evolved more complicated social patterns, engaged in rudimentary agriculture, traded with neighboring communities, and made crude pottery. Occasionally, they hunted in large, cooperative groups, driving the game to where it became immobilized and easy to kill. Archaeologists have found evidence in the Garden of the Gods indicating the butchering of bison and of medium-sized mammals, probably deer or bighorn sheep.

These people may have been early Ute Indians, the only group to have oral traditions of occupying the Colorado area from prehistoric times. Ancient rock art found in the Garden of the Gods is characteristic of Ute rock art.

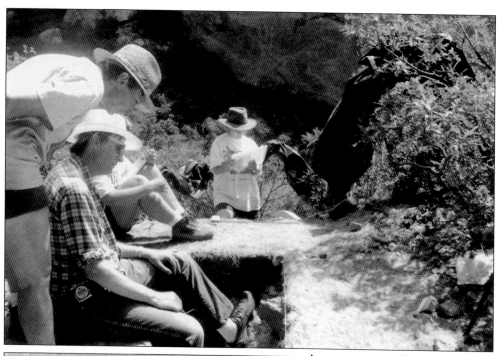

ARCHAEOLOGICAL DIG, 1996. Archaeological evidence found in the Garden of the Gods in 1993 indicates a presence of people in approximately 1330 BC, and a radiocarbon dating in 1996 indicates seasonal encampments by around 250 BC. The author (left) and Dr. Tom Wynn are in the left foreground. (UCCS.)

CORD-MARKED CERAMIC RIM SHARD. Biface stone scrapers, chert (flint) flakes, fire-cracked rocks, possible grinding stones, and a small shard of pottery typical of the Plains Woodland culture (AD 100–1000) were found while excavating several hearths and a rock shelter in July 1996. (CHS, VanNess.)

BIFACE SCRAPER OF PETRIFIED WOOD, PROBABLY AD 688–703. Stone scrapers were used by the Archaic and Woodland peoples to clean and prepare animal skins. (CHS, VanNess.)

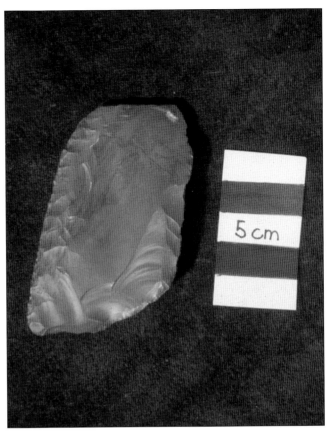

ANCIENT HEARTH. The hearths were not those of a living area because no charred animal bones were found nor was there any other evidence of long-term occupation. They were more than likely used in spiritual rituals. Judging from the evidence, the peoples using these encampments were of the middle to late Archaic period (3,000 BC–AD 500) and of the early Ceramic/Woodland period (AD 1–1,000). (UCCS.)

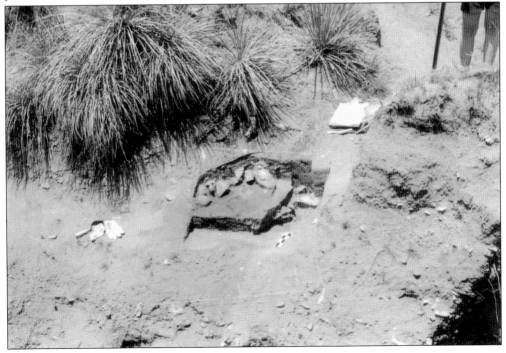

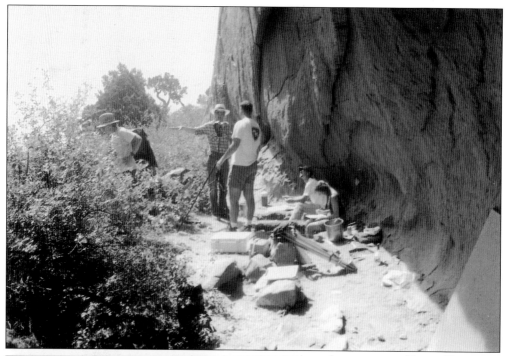

ARCHAEOLOGY DIG IN ROCK OVERHANG, 1996. The Archaic peoples were hunters and gatherers who camped under rock overhangs. They hunted small game (deer, antelope, and rabbit) as well as big game, foraged for vegetables and grain, and developed an assortment of tools. They heated stones in hearth fires and used them for heating their food in skin or fiber bags and possibly as a source of heat for small shelters. (UCCS.)

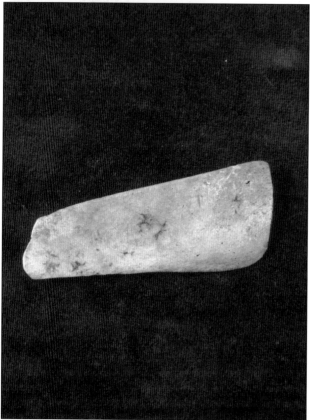

BONE TOOL. The modified scapula of a medium-sized mammal was used for scraping and smoothing clay during pottery manufacture (probably AD 688–703). The Ceramic or Plains Woodland culture, characterized by cord-marked pottery and small, side- and corner-notched points as well as other stone tools, appeared in Colorado around AD 100. (CHS, VanNess.)

PROJECTILE POINTS. Both points are characteristic of the Plains Woodland culture. These people appear to have subsisted on bison, elk, deer, antelope, rabbits, other small game, and wild plants. Archaeologists have found evidence in the Garden of the Gods indicating the butchering of bison and of medium-sized mammals, probably deer or bighorn sheep. (CHS, VanNess.)

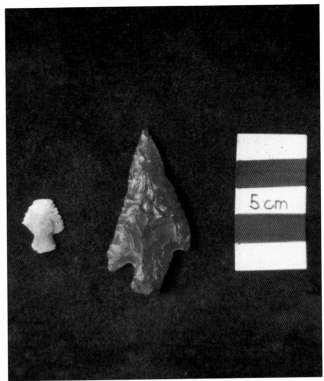

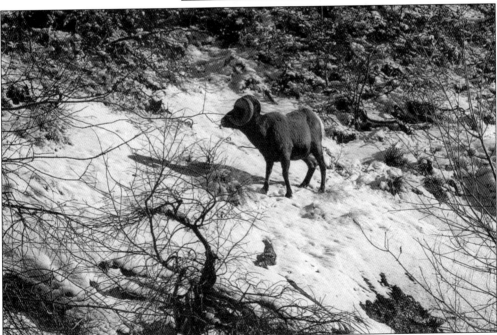

BIGHORN SHEEP. The Garden of the Gods is home to a variety of animals. Prehistoric hunters and gatherers found mule deer and bighorn sheep in the Garden of the Gods area. Jackrabbits and cottontails, skunks, badgers, chipmunks, prairie dogs, several colors of squirrels, coyotes, rock lizards, and numbers of birds were also available as food sources. (AC.)

27

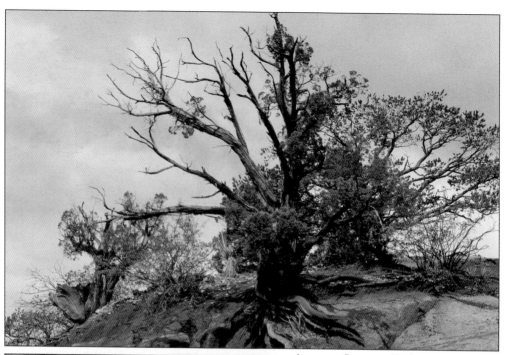

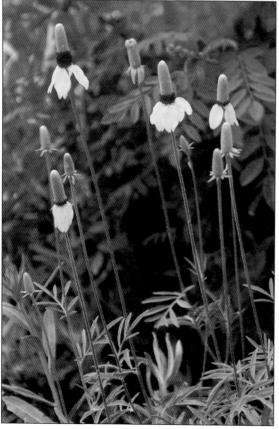

ANCIENT JUNIPER. Prehistoric people frequented the Garden of the Gods because of its abundance of plant and animal life. Native flora in the garden includes evergreen trees, such as juniper, white fir, red cedar, yellow pine, Douglas fir, and pinon pine. Some of the original junipers, such as these near Balanced Rock, are estimated to be 700 to 1,200 years old. Deciduous trees and shrubs abound as well. (AC, Evans.)

REDSPIKE MEXICAN HAT. Wildflowers like this Mexican hat as well as anemone, columbine, mariposa lily, Indian paintbrush, scarlet bugle, blue bells of Scotland, clover, thistle, poppy, common milkweed, wild geranium, golden aster, cactus, and Townsend daisy were abundant in the Garden of the Gods. Grasses included wild western wheat, gamma grass, sweet clover, and a little buffalo grass. (AC, Evans.)

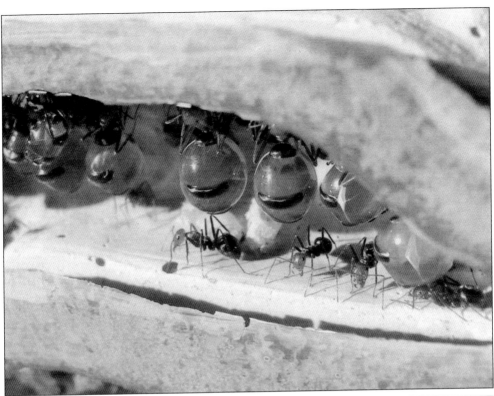

HONEYPOT ANTS. The Garden of the Gods is also home for colonies of rare honeypot ants, one of the world's most unusual species of ants because of its ability to store its food supply (nectar) in its abdomen. (AC, Greg Hume.)

GATEWAY THROUGH OLD TREES. According to Alden Naranjo, Southern Ute tribal historian, "Utes were created and they would always live in the mountains, up high in the mountains, they would be closer to Se-no-ee, the creator. Some would go down into the valleys and be there, but they were always going to be up in the mountains." (OCCHS.)

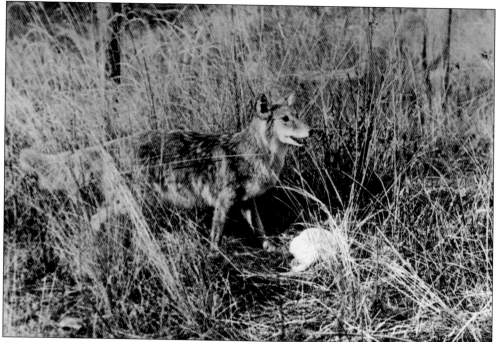

COYOTE. "The Utes were agreeable to the creator because they did not follow the crazy coyote, the creator's little brother, so they would always be in the mountains close to the creator," according to Alden Naranjo. (PPLD, Poley.)

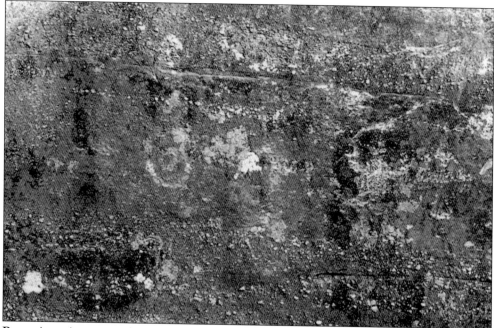

ROCK ART. Ancient rock art in the form of petroglyphs has been found in the Garden of the Gods. This particular rock art panel consists of five solid-pecked petroglyphs, consistent with the Umcompahgre Ute style of rock art. From left to right are a circle with a dot in the middle, a deer, a human figure, a thunderbird, and a possible bison. (CSPM, Wright.)

Three

AMERICAN INDIANS
SPIRITS AND BATTLEGROUNDS

The Utes were the only Indians along the Front Range of the Colorado Rockies until the early 15th century when the Apache came south looking for better hunting grounds. They became friends with the Utes and have oral traditions relating to the Garden of the Gods. Other tribes were pushed out of their homelands by the westward advance of the European Americans in the 1700s. The Kiowa were forced to move south from their home in south-central Montana by the Cheyenne and Arapaho, true Plains Indians. These tribes were also forced to move south and came to dominate the Great Plains between the Platte and Arkansas Rivers. These two tribes frequently passed through the Garden of the Gods and up the Ute Trail to South Park, occasionally waging war on the Utes. In 1859, the Utes fought a major battle with the Cheyenne, Arapaho, and Sioux six miles north of Colorado City and the Garden of the Gods in Woodman Valley.

Another tribe connected to the Garden of the Gods is the Shoshone, linguistic cousins of the Utes who traveled from northern Utah into Colorado. According to legend, after a dispute at the boiling springs in the 17th century, they broke into two tribes, the Shoshone and the Comanche. After the split, the Shoshone were primarily in Wyoming and Montana, and the Comanche stayed in eastern Colorado until they were forced from the Pikes Peak area in the late 1700s.

The Pawnees and the Lakota Sioux are two other tribes that claim a connection to the Garden of the Gods. The Pawnees say it is a religious site connected with their Morning Star tradition, and the Lakota say the Garden of the Gods is one of the four power centers of the earth and is the only place where all the plants of their pharmacopoeia may be found. Even though the Pawnee and Lakota had little physical connection with the Pikes Peak area, including the Garden of the Gods and the springs at Manitou, it is a spiritual place for them.

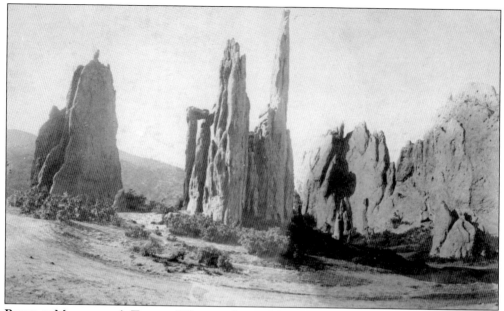

RUINS OF MONTEZUMA'S TEMPLE. When speaking of the Indian people, Alden Naranjo said, "We respect the ground that we walk on. We respect the things that are here. . . . There are places throughout the country where Indians have placed mounds and Medicine Wheels for a specific reason. There are places like Devil's Tower, Bear Butte, Garden of the Gods. Those are places that are special places for the Indian people." (CC.)

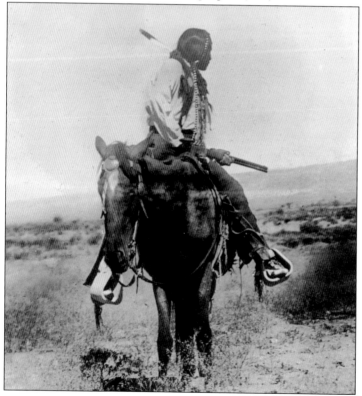

UTE ON GUARD. Indians believed that no one owned the territorial range they covered or the natural resources. The rights to use and manage a territory belonged primarily to the band or village that customarily lived, hunted, gathered, and traveled in that area. When groups were military allies and related to each other through kinship ties, they shared access to the use of a commonly held territorial range. (PPLD, Poley.)

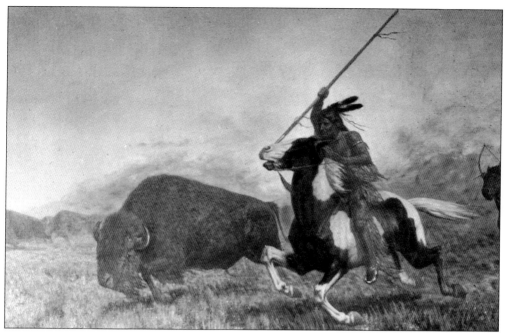

HUNTING BISON. Utes have the strongest connection of any Indian tribe with the Garden of the Gods. Their traditional lands occupied all the mountainous lands in Colorado from the Yampa River to the San Juan River and from the slopes of the Front Range to the present western border. They hunted buffalo as far out onto the plains as the shadows of the Rockies stretch at sunset. (PPLD, Poley.)

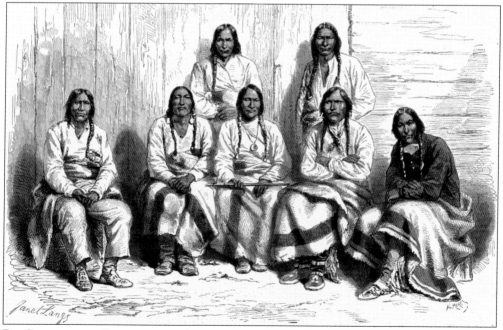

BIG CHIEFS OF THE CHEYENNE AND ARAPAHO. For centuries, the Utes were the only Indians along the Front Range of the Colorado Rockies until the Arapaho and Cheyenne moved into eastern Colorado, pushing the Comanche and Kiowa ahead of them. (PPLD, Lange.)

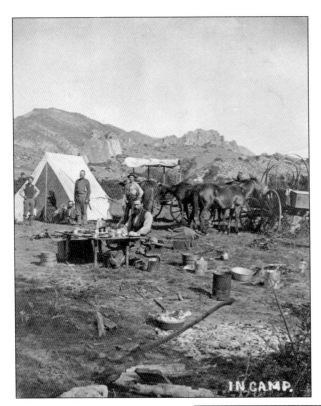

GOLD-SEEKERS IN CAMP SOUTHEAST OF THE GARDEN OF THE GODS. As more people came to Pikes Peak looking for gold after 1850, they killed off the buffalo, driving the Arapaho and Cheyenne into the mountains and into conflict with the Utes. (CC.)

PETRIFIED ANIMALS. The Utes have many legends about the Garden of the Gods, including one that tells of a great flood that covered the top of Manitou's Mountain; when waters subsided, the floating animal carcasses turned to sandstone and rolled down the peak into the valley below. (MSHC, Cunningham.)

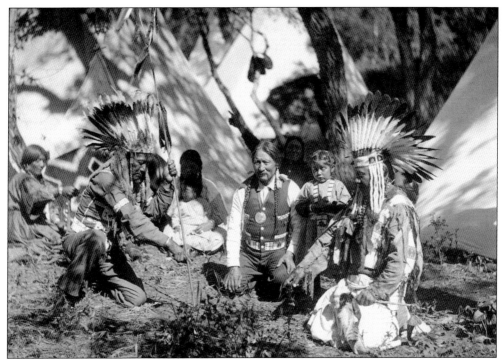

JOHN DEAL, BUCKSKIN CHARLIE, AND OCAPOOR, 1890–1900. The Garden of the Gods was the traditional winter and sometimes summer campground for the Mouache band of Utes who lived in the Front Range of the Rockies. The camp also consisted of members of the Tabewache and Capota bands. After other Indians moved into the plains, the Utes shared the area of Colorado Springs with them, according to Naranjo. (PPLD, Poley.)

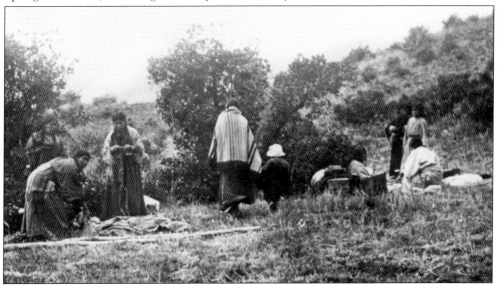

SELECTING CAMPSITE, 1890–1900. Utes generally made camp on a hill or high spot in a grove of trees that furnished protection from storms and provided firewood and was within walking distance of a spring or stream. Wickiups, domed huts about 15 feet in diameter and 8 feet high, were covered with willows, juniper bark, and grass with a fire pit in the center for warmth. (PPLD, Poley.)

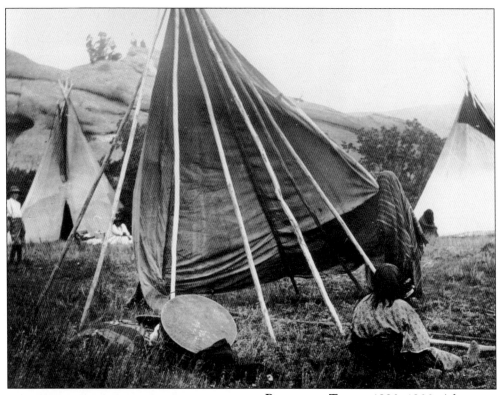

BUILDING A TEEPEE, 1890–1900. After the introduction of the horse, difficult-to-move, leather-covered teepees became more practical. Both the wickiup and the teepee had a fire pit in the center for warmth; however, the women did most of the cooking outside when weather permitted. An average of about five persons lived in each wickiup or teepee. As many as 55 persons lived in one village. (PPLD, Poley.)

YUCCA. The wildlife and abundant plant life in and around the Garden of the Gods made it a desirable place for the Utes to live. Yucca was one of the most useful plants. The blossoms and seeds are edible. The people made soap from the roots and rope and twine from the fibers in the leaves. (AC, Evans.)

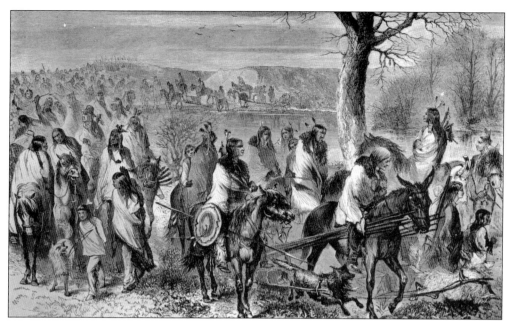

Moving. A witness described a move in 1873: "The Utes were moving camp with 400 ponies. The squaws loaded and packed the animals with tent poles, six on either side, with packs on top. One end of each pole dragged on the ground. On top of many of these packs, papooses, old enough to guide their ponies, were strapped on securely." (DPL, *Harpers Weekly*.)

Holes in Rocks. The Utes camped along Camp Creek outside the Garden of the Gods. Alden Naranjo told about the *Istubabi*, the little people or spirits who lived in the holes in the rocks. "These little people talked to the Utes so they didn't camp in the Garden of the Gods, they camped along Camp Creek, by Rockledge Ranch and toward Manitou Springs." (AC, Evans.)

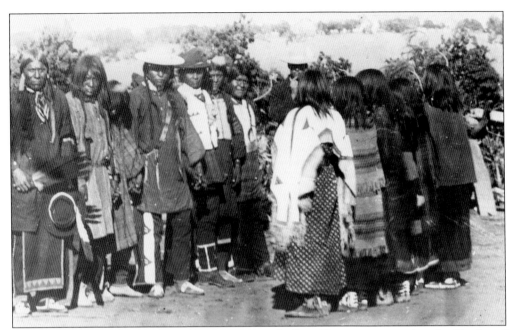

SPRING BEAR DANCE. The Ute's oldest ceremony, the Bear Dance, originated in the Garden of the Gods. People visit relatives, play games, mourn the deceased, and welcome new members. Couples pair off on the last day to dance together. Suddenly, the dancing ceases, and dancers dressed as a male and female bears spring into the circle, pawing and prancing, symbolizing that prayers are heard and the earth is awakened. (PPLD, Poley.)

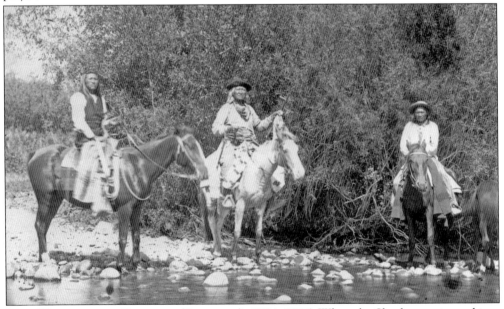

OITI, WASHAKIE, AND PAPPAGOIT (SHOSHONE), 1884–1885. When the Shoshone migrated into Colorado, they hunted buffalo, antelope, and other game on the plains, displacing the Apache, who moved south. Sometime in the 17th century, the Shoshone broke into two divisions, the Shoshone and the Comanche. A legend tells that the split occurred at the springs at Manitou Springs. (DPL.)

38

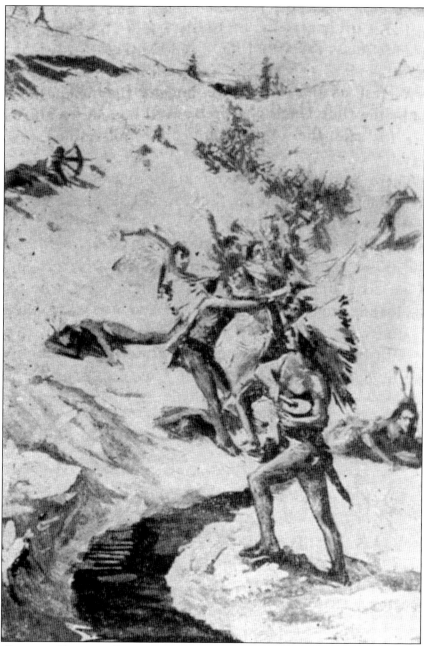

Battle Between Utes and Comanches, 1900. After the Shoshone and Comanche tribes split, the Shoshone were found primarily in Wyoming and Montana and the Comanche stayed in eastern Colorado, where they competed with the Apache for hunting territory and in raids upon the Spanish and Pueblo settlements in New Mexico. They procured Spanish horses, which they traded to their cousins—the Shoshone, the Ute, and the Pawnee—and to other tribes. In 1760, the Utes and Comanche had a disagreement and broke their alliance. For more than 100 years, they were at war, even though they were related people and spoke a similar language. In 1864, an attempt was made at peace, but somebody fired a shot so the Utes and Comanche did not make peace until 1974 at the Ute-Comanche Peace Treaty Powwow. (DPL, Drannan.)

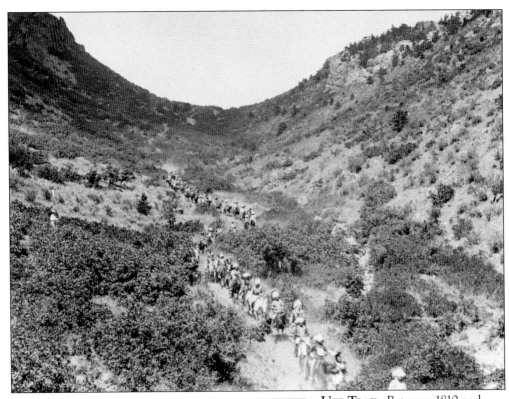

UTE TRAIL. Between 1810 and 1820, the Arapahos and the Cheyenne moved between the North Platte and the Arkansas Rivers and became traditional enemies of the Utes. Both tribes frequently passed through the Garden of the Gods and up the Ute Trail to the summer hunting grounds in South Park and occasionally waged war on the Utes around the Garden of the Gods and Ute Pass. (PPLD, Poley.)

RAINBOW FALLS. To the Arapaho, waterfalls and other natural spectacles were signs of the presence of the Great Spirit. The Utes and Arapahos equally claimed the Boiling Springs. The site of present-day Manitou Springs was the scene of many skirmishes between the Utes and Arapahos and other Plains tribes that occasionally visited the Boiling Springs. (MSHC, Chamberlain.)

UTE TRAIL. The Ute Trail was used by people for hundreds of years before the European discovery of America. This trail, one of the oldest documented routes of any of the Native Americans, was used for many generations by explorers, hunters, trappers, and Indians until the white settlers came, and even after that by occasional war parties until the Indians were driven from their traditional homes. (PPLD, Powell.)

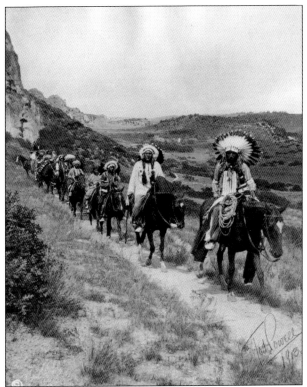

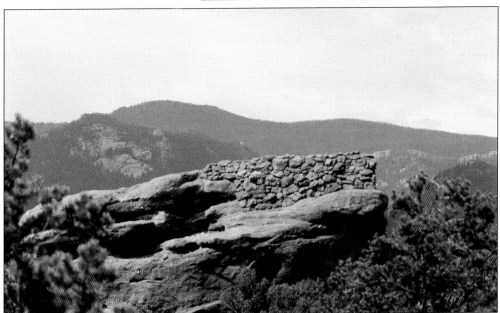

INDIAN FORT. Warfare was frequent between the Utes occupying the Garden of the Gods and other tribes who wanted to go up the pass. Several rock forts that offer advantageous lookout points have been found in the Garden of the Gods. Because of their height, a considerable area could have been kept under surveillance. In addition to the forts, the Indians took refuge in the cave in North Gateway Rock. (AC, Evans.)

NAVAJO SPRING (1870). The use of the Indian trail by early explorers led them to the Boiling Springs at Manitou. Dr. Edwin James, the botanist and historian of Col. Stephen Long's expedition who visited the Pikes Peak region in 1820, stated in his journal: "A large and much frequented road passes the springs [Manitou] and enters the mountains running to the north of the high peak." Rufus B. Sage states in his book *Rocky Mountain Life* (1846), "The Fontaine qui Bouille Creek is derived from two singular springs situated within a few yards of each other at the creek's head. . . . The Arapahos regard this phenomenon with awe and venerate it as a manifestation of the immediate presence of the Great Spirit. They call it Medicine Fountain and seldom neglect to bestow their gifts upon it whenever an opportunity is presented. These offerings usually consist of robes, blankets, arrows, bows, knives, beads, moccasins, etc. which they either throw into the water, or hang upon the surrounding trees." Dr. James also noticed the offerings. (MSHC, Jackson.)

Four

EXPLORES, TRAPPERS, AND TRADERS
JUST PASSING THROUGH

During the early 18th century, the Spanish actively explored the country north of the Arkansas River looking for gold and Indians for the priests to convert. In 1719 and 1720, two military expeditions traveled north of the Arkansas River and east of the mountains as far as the Platte River, possibly passing over the future townsite of Colorado Springs. Workmen digging a cellar in June 1894 uncovered a rusted iron box holding a handmade crucifix that had evidently been lost by a priest accompanying one of the Spanish expeditions.

A century later, Maj. S.H. Long's expedition to the Rocky Mountains secured the services of French trapper Joseph Bijeau as Indian interpreter and guide. Dr. James, the expedition botanist and geologist, described in his journal a lake sitting upon the divide between the Platte and Arkansas Basins. The party crossed this divide, noting a castle-like rock formation, then travelled along Monument Creek to a point just south of Pikes Peak where they camped so they could climb the peak and determine its altitude. Bijeau guided some of them to the boiling springs, and one of their members, Lt. William H. Swift, retrieved goods left in the springs by the Indians as offerings to the Great Spirit. Bijeau told the explorers French trappers often took articles from the springs and traded them to the Indians for skins.

Word of the beauty of the Pikes Peak area was spreading. Mountain man, author, and journalist Rufus B. Sage visited the Pikes Peak area in 1842 and described the scenes surrounding Manitou Springs in his book *Rocky Mountain Life*. He found the climate mild, the wildflowers enchanting, the game abundant, and the scenery heavenly. He thought it little wonder the Indians revered the place as home to the Good Spirit. This was just the beginning of the migration to the Pikes Peak area, the boiling springs, and the Garden of the Gods.

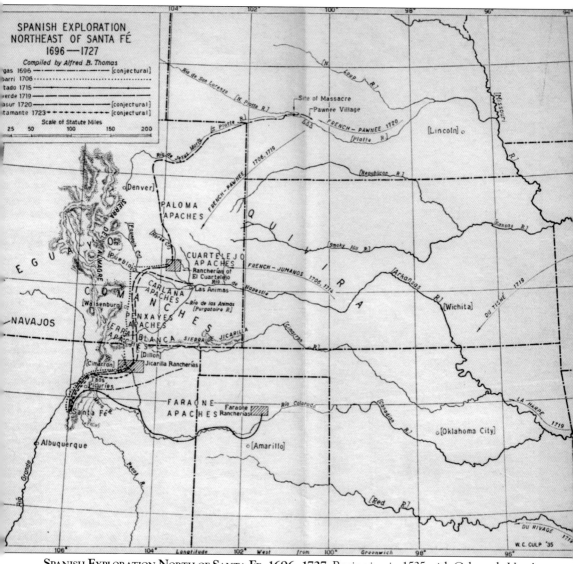

SPANISH EXPLORATION NORTHEAST OF SANTA FÉ 1696—1727

Compiled by Alfred B. Thomas

gas 1696 ————————— [conjectural]
barri 1706 ·····················
tado 1715 ————————
verde 1719 ————
asur 1720 ——— [conjectural]
tamante 1723 — · — · — · — [conjectural]

Scale of Statute Miles
25 50 100 150 200

SPANISH EXPLORATION NORTH OF SANTA FE, 1696–1727. Beginning in 1535 with Cabeza de Vaca's exploration of the North American southwest, Spain claimed a stretch of country of indefinite width east of the Rocky Mountains extending from Mexico north to the Yellowstone River. In 1763, Spain gained official ownership of the land from the Mississippi River to the Pacific Ocean through the Treaty of Paris. During the period of Spanish ownership, many people explored the region from Santa Fe to the Platte River. The earliest recorded Spanish expedition to the Pikes Peak area was in 1598. While digging a cellar on Pike's Peak Avenue in 1894, workmen uncovered an iron box rusted to the point of disintegration. Inside was a crucifix, attached to which was a Maltese cross having a small erect cross as a pendant, all handmade. None bore any inscription or date but possibly were lost by a priest accompanying one of the Spanish expeditions. (CC.)

MARIANO MADINA, ROCKY MOUNTAIN GUIDE, 1860–1870. Madina was a French–Native American guide, trapper, trader, and bounty hunter typical of the trappers from Canada who traveled Ute Pass to South Park during the 18th and early 19th centuries. Fountain Creek, first called Fontaine qui Bouille, or the "fountain that boils," because of its turbulence and because of the bubbling springs in the vicinity, was named by French trappers. (DPL, Carbutt.)

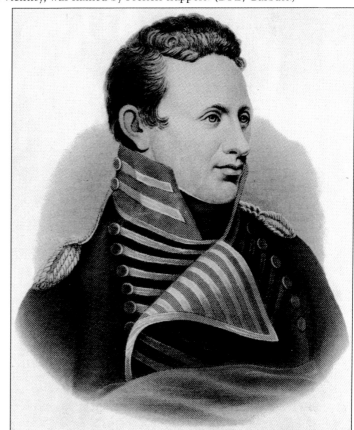

ZEBULON MONTGOMERY PIKE. In 1805, Pike traveled up the Fountain from the Arkansas River with the purpose of climbing the Grand Peak. On November 21, 1805, he succeeded in climbing a nearby mountain thinking it was the main peak; however, he never climbed the Grand Peak, nor made it to the north side of it. Thus he never saw the boiling springs or the Garden of the Gods. (PPLD.)

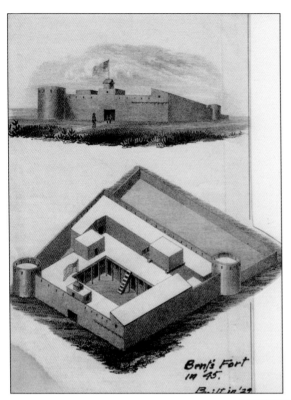

BENT'S FORT. In 1833, St. Louis brothers William and Charles Bent and Ceran St. Vrain opened a trading post fort on the Arkansas River. Bent's fort gave the mountain men a place to swap their beaver pelts for supplies and opened up the fur trade in the Colorado Rockies, which brought more trappers and traders through Ute Pass and into contact with the Garden of the Gods area. (CC.)

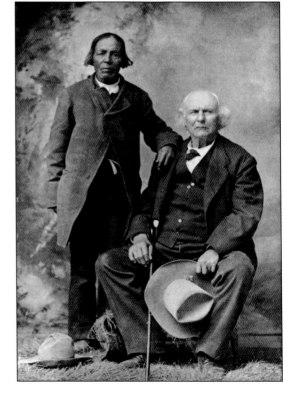

JESUS SILVA AND "UNCLE DICK" WOOTON. Joe Doyle, a trapper who worked for Bent and St. Vrain Co. in 1842, along with Dick Wooton and William Kroenig, owned the Soda Springs on the Fontaine qui Bouille in 1859. They planned to develop the springs into a spa they called the Saratoga of the West. Wooton built a small cabin next to the springs to stake his claim. (DPL, Sargent.)

MAJ. STEPHEN H. LONG AND EXPEDITION. In 1820, Major Long's expedition headed west, following the North Platte River, then south from Platte Canyon. Pikes Peak came into view on July 9 from the top of a mesa. They passed a lake sitting upon the divide between the waters that flow into the Platte and Arkansas Rivers. The party continued south along Monument Creek, and toward evening of the 11th day, they discovered they had passed the base of Pikes Peak. They stopped at this point so they could climb it and determine its altitude. Dr. James is credited with being the first white man to climb the peak, prompting Major Long to name it James Peak. The name lasted for 40 years until it changed to Pikes Peak. (Right, CC; below, Library of Congress, Childs.)

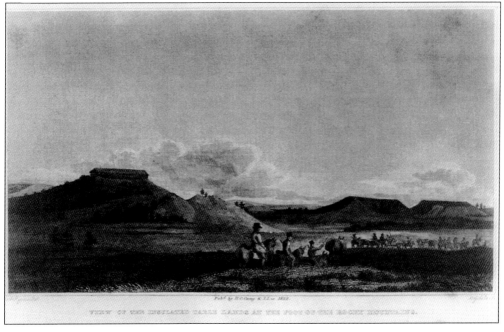

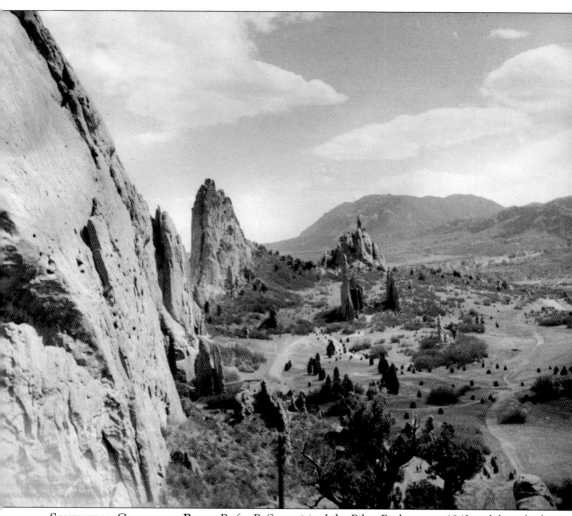

SOUTH FROM GRANDVIEW POINT. Rufus B. Sage visited the Pikes Peak area in 1842 and described the scenes surrounding Manitou Springs. "A few miles above Fountaine qui Bouit, and running parallel with the eastern base of the mountain range, several hundred yards removed from it, a wall of coarse, red granite towers to a varied height of from fifty to three hundred feet. This wall is formed of an immense strata planted vertically and not exceeding eight feet in thickness, with frequent openings—so arranged as to describe a complete line. The soil in which they appear is of a reddish loam, almost entirely destitute of other rock, even to their very base. This mural tier is isolated and occupies its prairie site in silent majesty, as if to guard the approach to the stupendous monuments of nature's handiwork that form the back-ground, disclosing itself to the beholder for a distance of over thirty miles." (CC.)

JOHN FREMONT AND KIT CARSON. In 1843, John C. Fremont with Kit Carson as guide went from the mouth of the Fountain to the springs of Manitou. "Went up the 'Fountaine-qui-bouit' river to sample the springs. . . . There is a handsome little bottom on the right and both banks are exceedingly picturesque . . . strata of red rock, in nearly perpendicular walls, crossing the valley from north to south. About three miles below the springs, on the right bank, is a nearly perpendicular limestone rock, presenting a uniformly unbroken surface, twenty to forty feet high, containing very great numbers of large univalve shells. . . . To the westward, was another stratum of limestone, containing fossil shells of a different character; and still higher up on the stream were parallel strata, consisting of a compact somewhat crystalline limestone, and argillaceous bituminous limestone in thin layers." (Right, CSPM; below, DPL, Barry.)

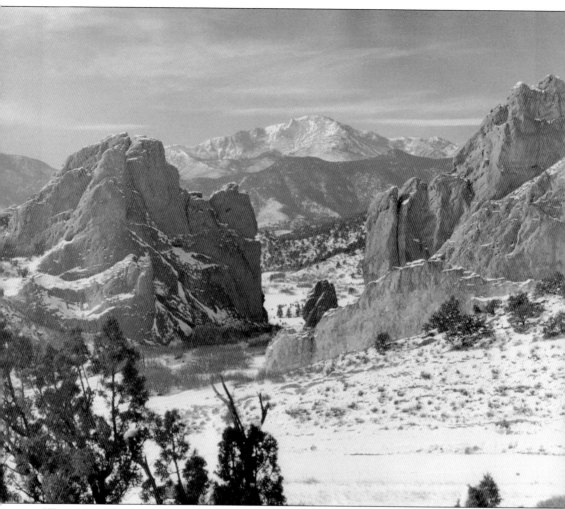

WINTER IN THE GARDEN. Trapper Jacob Spaulding and two companions camped in the Garden of the Gods during the winter of 1848–1849 after failing to find a pass through the mountains. During the first week of November, four feet of snow fell and two mules had to be destroyed to keep the animals from starving; the other pair were fed on bark and tree branches. Spaulding discovered a cavern hidden inside North Gateway Rock, 200 feet long, 5–15 feet wide, and nearly 100 feet high. A stream of cold water trickled down from the ceiling. He found tracks of bobcat and mountain lion on the floor. He also discovered the cave was a good echo chamber. Spaulding moved on in the spring, but he returned in 1862. (CC.)

Five

MINERS, SETTLERS, AND ENTREPRENEURS
EUREKA!

Calvin Clark, a Pikes Peak gold-seeker, noted in August 1859 that numerous names had been cut into White Rock. Many who carved their names came seeking gold, and others found their fortunes in commerce with the gold-seekers. Melancthon S. Beach established a trading post at the entrance to Ute Pass. Horace Tabor, a small-time grocer, hauled supplies up Ute Pass to the gold camps in South Park. Still others moved on and made their fortunes elsewhere.

As more people came to the Pikes Peak area, new towns sprung up. Buffalo and wildlife were killed or driven away. The Utes continued their seasonal camps in the Garden of the Gods, giving the area settlers little trouble. The Cheyenne and Arapahos respected the fighting ability of the Utes and generally left the settlers of Colorado City alone but still made raids on ranches and settlements. After the Battle of Washita in 1868, most of the Cheyenne and Arapahos were placed on reservations. The Utes were sent to reservations in 1878.

With worries about Indian attacks minimized, the people of Colorado City went on about their lives. Interested in a possible route for his railroad, General Palmer returned to Colorado City in 1869. He wrote, "Pikes Peak never looked grander, and the Garden of the Gods fascinated my companions of the Eastern frontier so that they bubbled all over with enthusiasm, resembling the Soda Springs, from which we drank great quaffs, as Dr. Bell and I had done."

As General Palmer was protecting the image of the Garden of the Gods, scientists were making an important discovery beneath the surface. In 1878, Professor Kerr of Colorado College discovered fossils of "21 different sea monsters" in one of the ridges forming the east boundary.

General Palmer, who did not carve his name in the rocks, passed away in his home at Glen Eyrie at the age of 72. The dream he and Charles Perkins had of keeping the Garden of the Gods unspoiled for the free use of everyone has lived on as a city park.

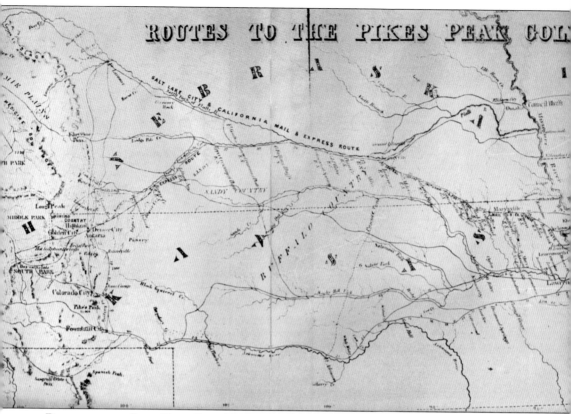

ROUTES TO THE PIKES PEAK GOLD REGIONS. A large number of gold-seekers passed through the Pikes Peak area in their search for riches. Some 118 names were carved into the rocks of the Garden of the Gods between 1731 and 1890. Calvin Clark, a Pikes Peak gold-seeker, noted in August 1859 that numerous names had been cut into White Rock. Inside the cavern in North Gateway Rock, many of the earliest pioneers carved their names with dates upon the walls. The cave was reopened in 1935, but it was impossible to identify many of the names with the dates because the carvings were so numerous and so irregularly carved. The cave has since been permanently sealed for safety reasons. (CC.)

AUTOGRAPH ROCK. More than 30 of the people who carved their names on rocks in the Garden of the Gods have been identified. Now carving anything into the rocks is forbidden as a measure to protect the historic names and dates and to protect the rocks themselves. (PPLD, Zelley.)

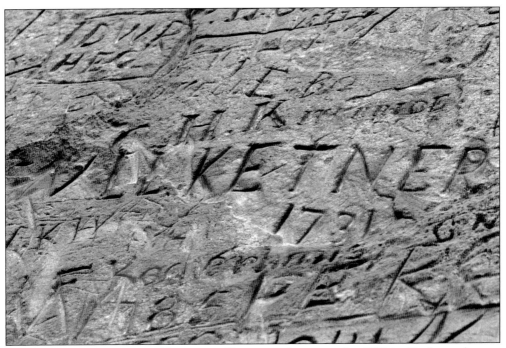

KETNER AND KOCHERHONS. Above a small cave on the west side of White Rock are the two oldest names within a few inches of one another: "WLL Ketner 1731" and "F Kocherhons 1785." Parties of French trappers and traders were in the area in the mid- to late 1700s, and Ketner and Kocherhons were possibly among them. (AC, Evans.)

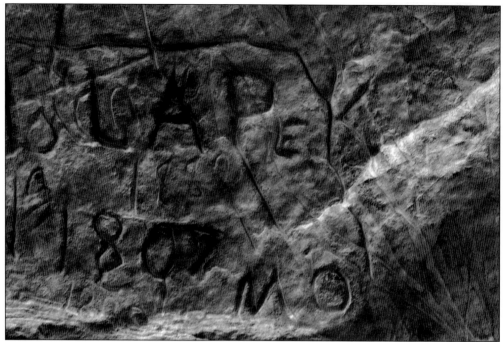

H. LAPE. Another early name and date is found above the same cave on the west side of White Rock. The carving "H LAPe 1807 MO" is difficult to read because of the presence of later carvings. If this name is authentic, it probably belonged to a French trader or trapper from St. Louis. (AC, Evans.)

ALEXANDER AIRFIELD, 1920s. A Dutch gold-seeker from Iowa named John Huiscamp had to spend the winter of 1850–1851 camped in the Garden of the Gods with the Utes, probably because of a broken wagon axle. In the spring, he followed his Ute friends up the pass into South Park. His descendants returned to Colorado Springs to open Alexander Aircraft and Film Company in 1919. (PPLD.)

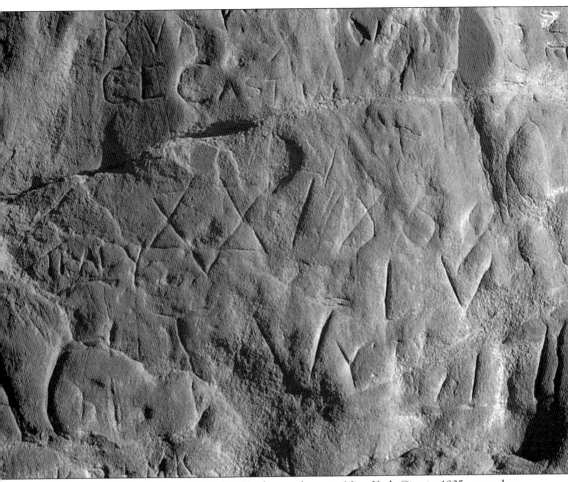

A.C. WRIGHT, 1858. Andrew C. "Jack" Wright was born in New York City in 1835, moved to Lawrence, Kansas, in 1855, and was a member of the Lawrence party that camped on Camp Creek July 8–August 10, 1858. The Lawrence party moved to the Russell Diggings at the mouth of Cherry Creek that September. By October 1, Wright had moved to Henderson Island where he camped with William McGaa, Bill Roland, and Jim Saunder. When word came of the organization of St. Charles (later Denver City) by the Lawrence party, Wright and his new companions decided to return to the mouth of Cherry Creek. On the west bank of the creek, they built a two-story log cabin. The town of Auraria was soon laid out around it. By the spring of 1860, Andrew Wright was back in the Pikes Peak region, probably living in Colorado City. He married Cordelia Ricker from Lawrence, Kansas. They had two children and finally settled in Denver where Jack opened Denver's first livery stable with George Estabrook. (AC.)

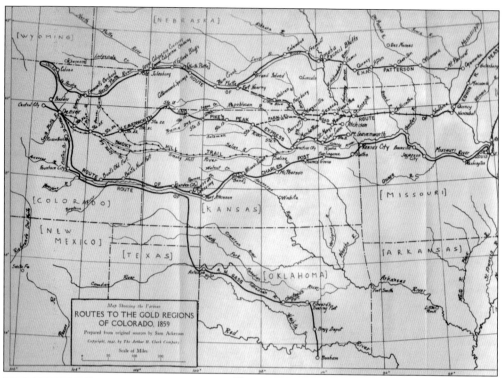

ROUTES TO GOLDFIELDS. "Wm Hartley 1858" (south side of Autograph Rock) was with the Lawrence party during the move to the Russell Diggings in September 1858. A civil engineer and surveyor, he helped lay out the town of St. Charles on 640 acres east of the Platte River and Cherry Creek. After laying out the town, the group, including Hartley, decided to spend the winter in Lawrence, Kansas. (CC.)

HAND-BOOK

TO

KANSAS TERRITORY

AND THE

Rocky Mountains' Gold Region;

ACCOMPANIED BY RELIABLE MAPS

AND A

PRELIMINARY TREATISE

ON THE

PRE-EMPTION LAWS OF THE UNITED STATES.

BY

JAMES REDPATH AND RICHARD J. HINTON,
OF KANSAS.

New York:
J. H. COLTON, PUBLISHER,
172 WILLIAM STREET.
1859.

GUIDEBOOK. The St. Charles townsite was jumped by the Larimer party from Leavenworth, Kansas, resurveyed and renamed Denver City. William Hartley and T.C. Dickson collaborated on a descriptive guidebook to the newly discovered gold regions. This was among the first of many written for sale to the fifty-niners. A copy could be obtained by mailing $1 to Wm. Hartley and Co., St. Louis, Missouri. (CC.)

TRAIL UP AND SUMMIT OF PIKES PEAK. Augustus Voorhees ("A S Voorhees," inside North Gateway Rock), born in New York on December 14, 1828, was the only member of the Lawrence party to keep a daily diary. Voorhees's diary entries began on May 31, 1858, and continued until July 12, the date when the gold-seekers moved from the Garden of the Gods to Jimmy Camp. From July 8 to July 11, Voorhees and two others climbed Pikes Peak. In the fall of 1858, he returned to Kansas with other members of the Lawrence party. When the Civil War broke out, he enlisted in the Fifth Kansas Cavalry, serving for three years. Later, he moved to Wisconsin, then in 1890 returned to Kansas where he died in 1905. He was married and raised a family of seven. (Right, DPL, Duhem Brothers; below, PPLD, Gurnsey.)

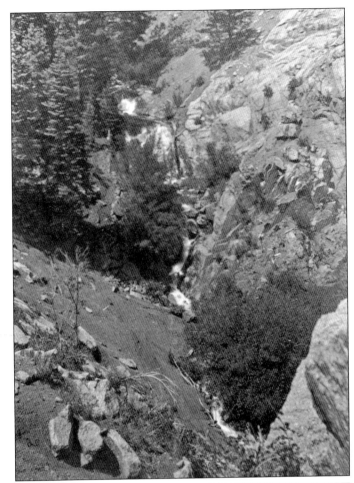

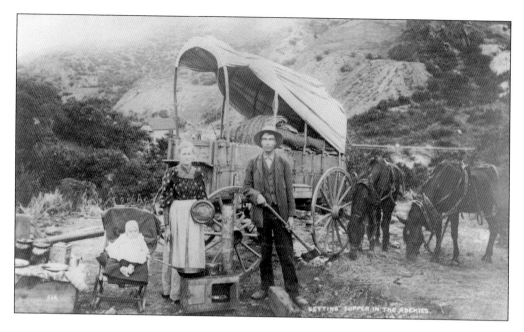

FAMILY CAMPING AND RETURNING FROM THE SUMMIT. James H. and Julia Archibald Holmes were members of the Lawrence party. For more than a month, they lived out of their wagons in the Garden of the Gods and panned for gold. They carved finger rings and pipes out of soft gypsum that covered the back side of White Rock and played euchre and cribbage. Several members of the party climbed Pikes Peak. Julia Archibald Holmes, later known as the "Bloomer Girl," was the first white woman to make the ascent. They stayed on the summit for two days, and Julia wrote letters to the eastern press dated July 1858. A season of heavy, continuous rain set in so they moved into the cave in North Gateway Rock where they carved their names and the smoke from their fires blackened the walls. (Above, CC; below, PPLD, Thurlow.)

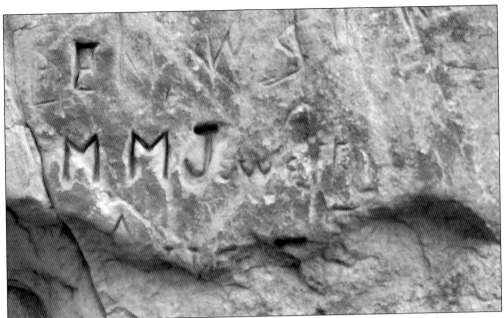

"M M Jewett Aug. 70," North Gateway Rock. Marshall Jewett was a member of the Larimer party of gold-seekers, which was organized at Leavenworth in September 1858. They arrived in Auraria on November 16, 1858, and jumped the Lawrence party's claim to the townsite of St. Charles. Their town, Denver City, was named in honor of James W. Denver, governor of Kansas. (AC, Evans)

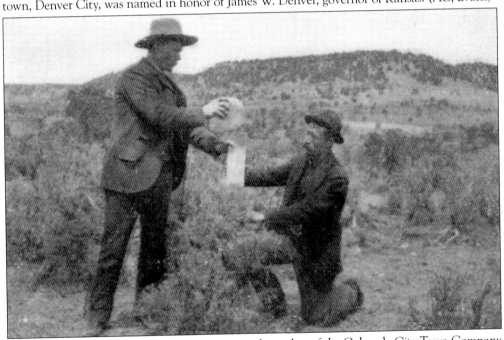

Driving the First Stake. Jewett was an original member of the Colorado City Town Company organized in 1859 to layout a town at the entrance of the Ute Pass at the base of Pikes Peak. M.S. Beach and R.E. Cable rode down from Denver and located the townsite on 1,280 acres, one mile by two miles above the mouth of Camp Creek toward Monument Creek. This lithograph was made in 1895. (PPLD.)

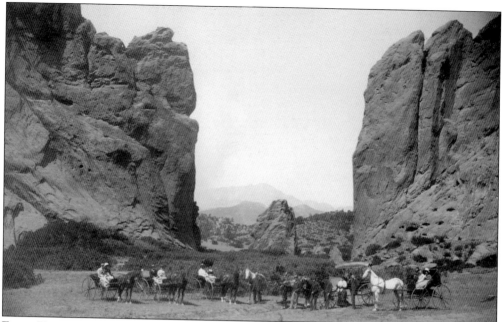

EARLY TOURISTS AT GATEWAY. John Coplen ("j Coplen 1860," North Gateway Rock), age 18, came to Colorado City from Ohio in 1860 with his parents, William and Ruth. He fought with Company G, 3rd Regiment, Colorado Volunteer Cavalry in the Indian Wars of 1864. This regiment fought under the command of Col. John M. Chivington at Sand Creek. After mustering out, Coplen filed a land claim in Black Forest. (OCCHS.)

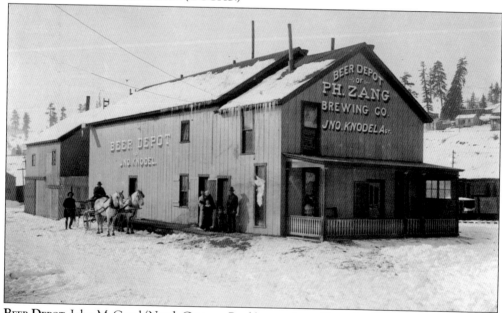

BEER DEPOT. John M. Good (North Gateway Rock) came from Alsace-Lorraine, France, and joined the gold rush. At Denver City in 1859, he opened a general store, freighting his goods overland from Missouri. He established the Rocky Mountain Brewing Company, later selling it to Philip Zang. Good accumulated a fortune investing in mining, banking, railroad, and real estate and was twice appointed treasurer of Denver, where he died November 24, 1928, at 84. (DPL.)

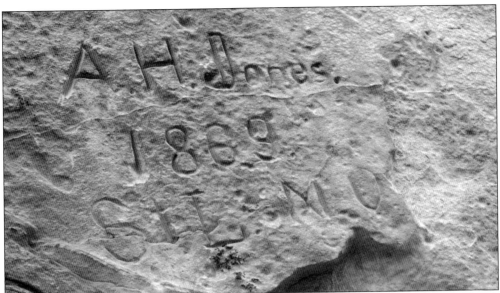

"A.H. JONES 1869 ST. L MO," WHITE ROCK. Albert Jones fought with the 9th New York Infantry during the Civil War until severely injured by a gunboat's falling mast. Jones opened a wholesale liquor store in Denver in 1866. He organized the Chaffee Light Artillery Company and was brigadier and inspector general of the Colorado National Guard and US marshal for Colorado. He died in Denver on November 16, 1910. (AC, Evans.)

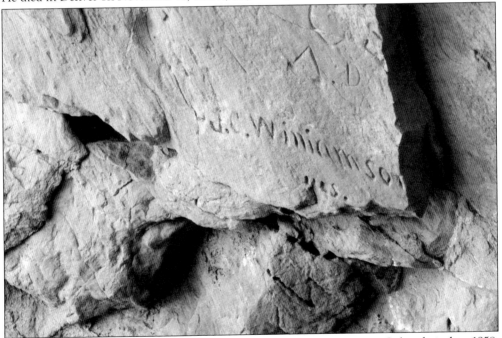

"J.C. WILLIAMSON," NORTH GATEWAY ROCK. John Williamson came to Colorado in late 1858. In 1859, he went to search for gold along St. Vrain's Fork. Later, Williamson married and settled down on Glen Plym Ranch in the mountains among red rocks near modern-day Littleton. He, his wife, and blind son Willie lived on the ranch for 37 years. The "Sage of Glen Plym" died at 87 in 1911. (AC, Evans.)

HALF-CENTURY CLUB, 1922. On April 7, 1863, Louisa (fifth woman from right, "Mrs. Lou Frost 1870," cave inside North Gateway Rock), age 19, and her parents joined a wagon train headed west, reaching Colorado after several encounters with Indians. Louisa married Edward Frost, government scout, Indian fighter, and Civil War veteran. They lived at St. Vrain's fort and Colorado Springs, raising three sons. Louisa died in 1936 at age 90. (CSPM.)

HALF-CENTURY CLUB. In 1859, after gold was discovered in the Terryall District in South Park, Melancthon S. Beach (second row, left) established a trading post at the entrance to Ute Pass. Beach organized the Colorado City Town Company in Denver. With Rufus E. Cable as his guide, they made the trip down from Denver on horseback and staked out Colorado City on August 14, 1859. (CSPM.)

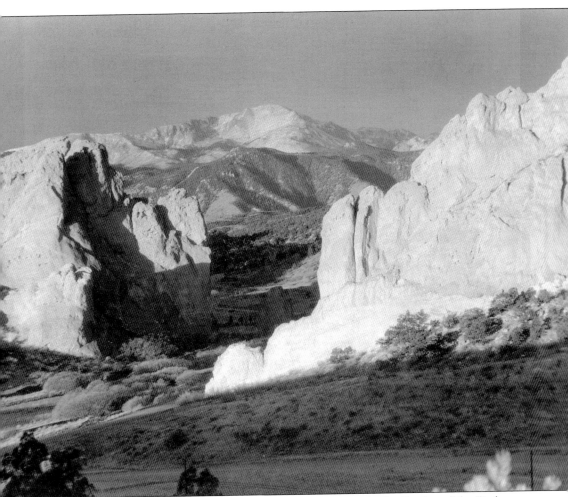

GATEWAY TO THE GARDEN OF THE GODS. According to M.S. Beach, the Garden of the Gods was named by Rufus Cable. Beach states: "Cable was then a young and poetic man, and when we visited the site together I suggested that it would be a capital place for a beer garden when the country grew up. He exclaimed, 'Beer garden! Why, it's a fit place for the gods to assemble. We will call it the Garden of the Gods' and by that name it was known from that date." Although this name was universally recognized from that time, the locality was more often spoken of by the early settlers as the "Red Rocks." (CC.)

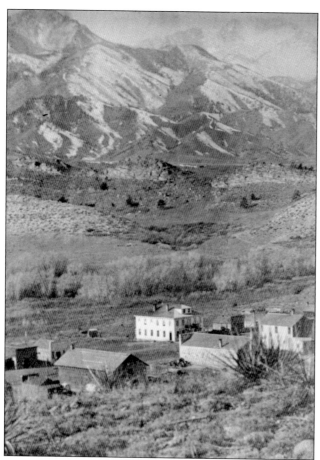

COLORADO CITY, 1860, AND BUGGY BETWEEN STEAMSHIP AND BALANCED ROCKS. The morning edition of the *Missouri Democrat* dated Tuesday, March 20, 1860, ran the following letter by Professor Goldrick (editor of the *Rocky Mountain Herald* in 1924). He was writing from Colorado City, March 1, 1860, and speaking of the location of Colorado City and Pikes Peak: "Its huge and lofty castled domes and towers of variegated rocks and sandstone pyramids, which stand around the outskirts, and especially adjoining the Garden of the Gods, like towering sentinels who have held their position there since Noah's flood, these ponderous pedestals and eruptive entablatures, terrace above terrace, and these hillocks of conglomerations and petrifactions, lying, as it were, in a regular confusion, are a curiosity and a study for . . . geologists." (Left, CC; below, OCCHS.)

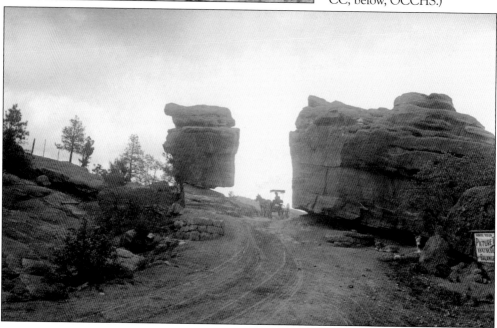

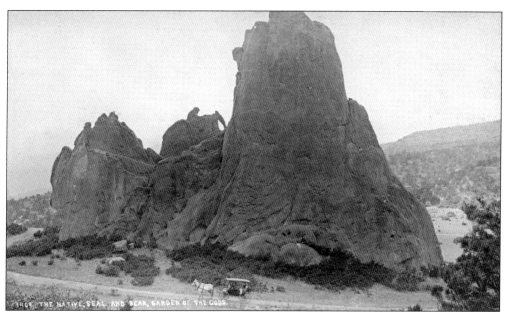

SEAL AND BEAR (ABOVE) AND
SIMPLETON. Opie Read wrote in
the *Gazette Telegraph* on January
1, 1905, "In this mysterious
place, what jolts there are to the
imagination! In its myriad of
animal shapes it is the menagerie
of eternity, petrified; and but
for its grandeur it would be a
verbal storm. It is earth's most
weird emotion caught and
stilled. . . . Milton's Satan would
have claimed it for his theater.
. . . From it Carlyle might have
caught the ruggedness of his
style. Profanity would term it
the brick kiln of hell. Humor
would call it the delirium tremens
of nature. But truth proclaims
it magnificent beyond poet
or painter. Mingling with the
terrible there is the sublime. It
is a hushed Wagner, a tragedy
of silent music, a Godtune
terrific." (Above, MSHC, Davis;
right, MSHC, Hersom.)

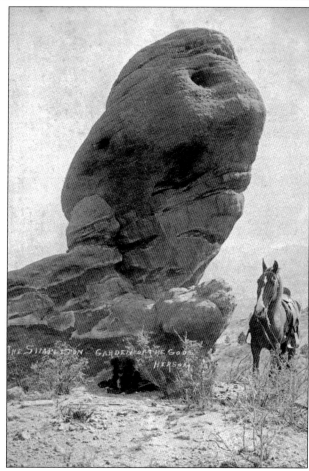

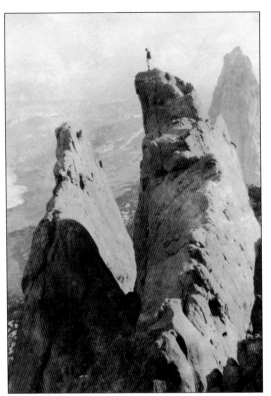

"GRAND SENTINELS OF RED GRANITE." Thomas E. Townsend, an early resident, expressed his feelings on his first visit to the Garden of the Gods. "The effect was one of peace rather than agitation, a reverence, a peace, such as you find in old cathedrals and churches abroad. . . . The grand sentinels of red granite and other wonderful formations alone stood there silent in all their glory." (CC.)

HELEN HUNT JACKSON. Helen Hunt Jackson wrote in her book *Bits of Travel at Home,* "I doubt if one ever loved the Garden of the Gods at first sight. One must learn it like a new language I have fancied that its speech was to the speech of ordinary nature what the Romany is among the dialects of the civilized; fierce, wild, free, defiantly tender." (CC.)

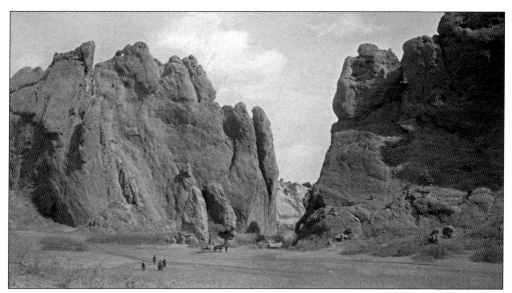

GATEWAY ROCKS (ABOVE) AND
HOBGOBLIN OR SENTINEL. In *The Heart
of the Continent*, Fitz Hugh Ludlow
wrote of the Garden of the Gods, "This
fanciful name is due to the curious forms
assumed by red and white sedimentary
strata which have been upheaved to a
perfect perpendicular on a narrow plain
. . . with summits worn by the action
of wind and weather into their present
statuesque appearance. . . . it would
not be difficult to imagine some of the
curious rock-masses petrified gods of
the old Scandinavian mythology. These
masses, upon their east and west faces,
are nearly tabular. . . . Two of the loftier
ones make a fine portal to the gateway
of the garden. Their red is more intense
than that of any of the sandstones I
am acquainted with, in a bright sun
seeming almost like carnelian." (Above,
MSHC, Heine; right, MSHC.)

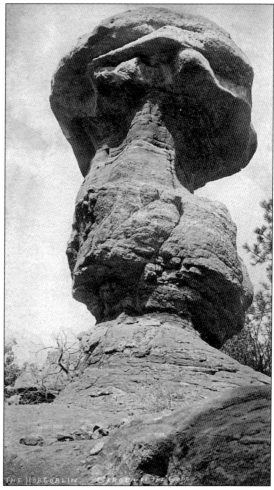

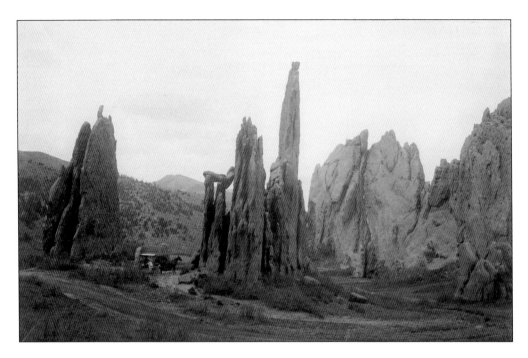

CATHEDRAL SPIRES (ABOVE) AND DOLPHIN AND EAGLE. Ludlow goes on, "One of the . . . red rocks resembles a statue of Liberty standing by her escutcheon, with the usual Phrygian cap on her head. Still another is surmounted by two figures which it requires very little poetry, at the proper distance from them, to imagine a dolphin and an eagle aspecting each other across a field gules. The spine-cracking curve of the dolphin, and his nice, impossibly fluted mouth would have delighted any of the old bronze-workers." (Above, OCCHS; below, MSHC, Jackson.)

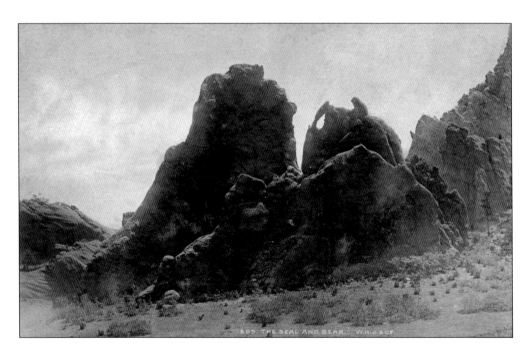

MOTHER GRUNDY. According to Ludlow, "Another rock resembles a pilgrim (poetical, not Plains variety) pressing forward with a staff in his hand." (CC.)

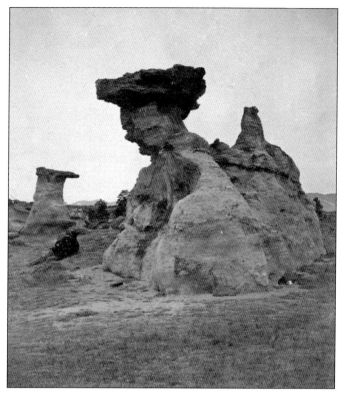

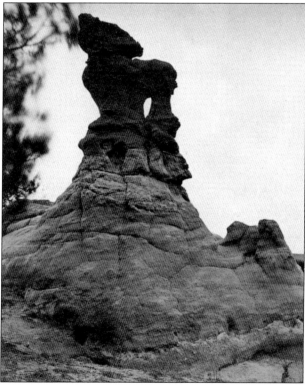

GRIFFIN. "Another is supposed to look exactly like a griffin. Indeed, from the right point of view one feels that a griffin must very probably look thus, though the difficulty of comparing it with an original specimen prevents absolute certainty," according to Ludlow. (CC.)

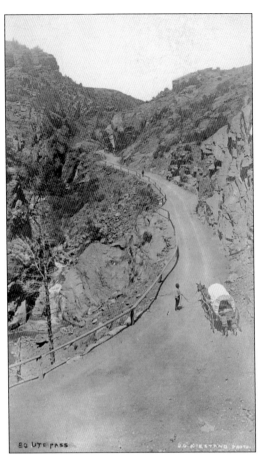

PUSHING WAGON UP UTE PASS. The descriptions and the discovery of gold in 1859 brought more people to the Pikes Peak area. A greater population required better means of travel than foot and horseback. A narrow road was built following the old Ute Trail. Because two wagons could not pass at one time, traffic went uphill in the morning and down in the afternoon. (MSHC, Hiestand.)

HORACE AUSTIN WARNER TABOR. In 1859, Colorado prospector, mine owner, and US senator Horace Tabor, at that time a small-time grocer from Colorado Springs, hauled supplies up Ute Pass to the gold camps in South Park. The trip took him two weeks at five miles a day with a wagonload of flour, sugar, pork, and other trade goods. (DPL.)

POSSIBLE LOCATIONS OF COLORADO TERRITORIAL LEGISLATURE. The first Territorial Legislature of Colorado met in Denver on September 9, 1861, and voted to locate the capital at Colorado City because it is the geographical center of Colorado. The second legislature met at Colorado City on July 7, 1862. Judge Wilbur F. Stone who took part addressed the El Paso County Pioneer Society on September 25, 1906. "The Council assembled in the kitchen of old Mother Maggard's log tavern. The body took a recess while the cooking was in progress. . . . The members of the House batched in their little assembly room, took turns cooking at the fireplace, . . . carried water in pails from the creek, and slept at night on the floor." They were dissatisfied and after convening changed the capital to Denver. No one seems to be sure which building was the actual location. (Above, CC; below, MSHC.)

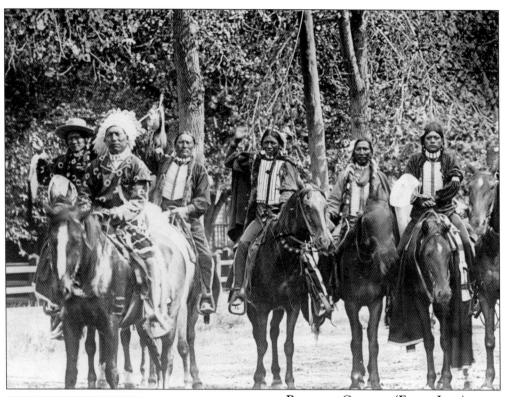

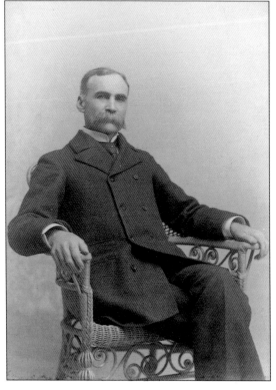

BUCKSKIN CHARLEY (FRONT LEFT) AND INDIANS ON HORSEBACK. Many Indians were unhappy about the white men taking over their hunting grounds. It would have been easy for the Cheyenne and Arapaho on the eastern frontier of El Paso County to reach Colorado City without being observed. However, they knew they ran the risk of having to fight the Utes, whose fighting ability they respected, as well as the whites. (PPLD, Poley.)

IRVING HOWBERT, 1890. Howbert's ranch was on Camp Creek above Colorado City. In 1864, Howbert was helping his brothers drive cattle into a corral when he saw six mounted Indians leading an extra horse. Howbert got help and went after the men who were a scouting party for the Cheyenne, Arapahos, and other hostile Indians. Some escaped, some were killed, and an attack on Colorado City was prevented. (CC.)

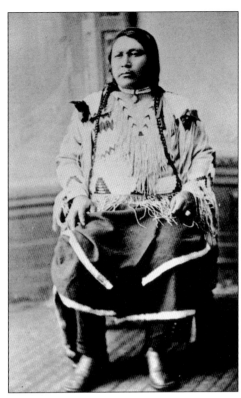

UTE CHIEF OURAY, 1880 (RIGHT) AND UTE CHIEF COLOROW, 1890. During the winter of 1865–1866, a camp of 300 Ute Indians stayed for several months on the south side of Fountain Creek opposite Colorado City, and again in the winter of 1866–1867, about 1,000 or more camped for several months below the boiling springs at Manitou between Balanced Rock and Fountain Creek. Snow was deep, game was scarce, and the Indians were starving. Finally, Chiefs Ouray and Colorow made a demand on residents of Colorado City for 20 sacks of flour and intimated that unless it was produced forthwith, they would have to march into town and take it by force. The residents gave flour. This was the only time in the early period that Colorado City suffered from the presence of the Utes. (Right, PPLD; below, PPLD, Poley.)

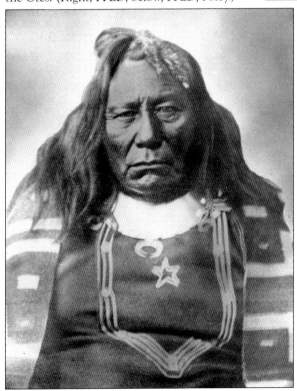

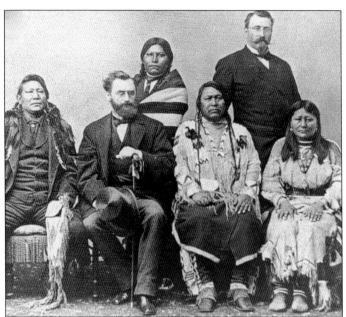

CHIEF IGANCIO, CARL SHURZ, CHIEF OURAY, CHIPETA, WORETSIZ, AND GEN. CHARLES ADAMS. The Utes continued to frequent the Garden of the Gods area through the 1870s. Their summer encampment of 1878 was the last because of the treaty made in Washington, DC, with Chief Ouray in which the Utes agreed to go to reservations. Most Arapaho and Cheyenne had gone to reservations in 1868. (PPLD, Poley.)

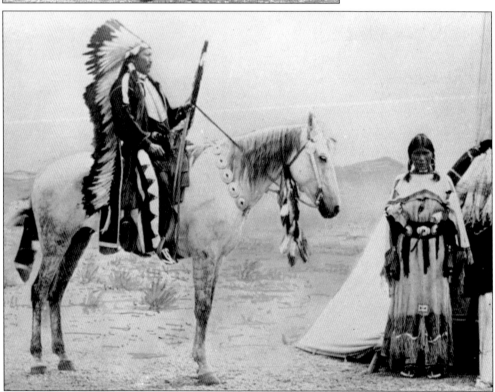

BUCKSKIN CHARLIE AND WIFE. During one summer, more than 500 Utes camped along Camp Creek. The Utes had horse races on the narrow, level plain on the mesa between Colorado Springs and the Garden of the Gods. The track, several miles in length, was worn into two tracks or ditches in the hard surface, which was about four feet wide and two feet deep. Braves were also observed running down and catching antelope. (PPLD, Poley.)

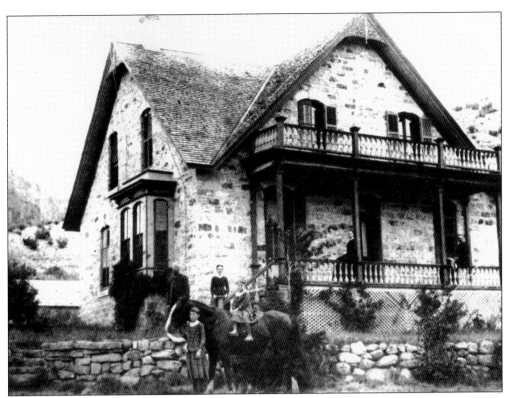

ROCKLEDGE RANCH AND THE ROBERT M. CHAMBERS FAMILY, AROUND 1880. The Garden of the Gods had one small spring that did not appeal to most incoming settlers. They had to have sufficient water to raise crops. Some attempted ownership for grazing, quarrying of gypsum, or similar purposes. Walter Galloway claimed a quarter section and built a log cabin but lived in town. In 1874, Robert Chambers bought the Galloway homestead for $1,400. He built a new house of stone, put in six acres of asparagus, and planted hundreds of apple and cherry trees. He dug a reservoir on the backside of Niobrara Ridge for water irrigation. Traces of the fruit trees and the reservoir can still be seen today. The ranch has been preserved in its natural state and is used as a center to study the environment and the historic past. (Above, PPLD; right, PPLD.)

L.N. Tappan, Colorado Volunteer, 2nd Cavalry Regiment. "Uncle Dick" Wooton sold the Soda Springs in 1859 to Whitsitt and Company for $500. Whitsitt sold to one of the Tappan brothers from Boston. The claim was jumped by a man named Slaughter. The acreage around the springs was either jumped or sold several more times until George Crater from Denver bought it from Colonel Chivington's son-in-law for $10,000. (DPL, Lewis.)

Gen. William Jackson Palmer. In 1869, General Palmer wrote as he traveled from Pueblo to Denver, "At Colorado City, the Garden of the Gods, we stopped to breakfast. I freshened up by a preliminary bath in the waters of the Fountain. Near here are the finest soda springs and the most enticing scenery. I am sure there will be a famous summer resort here soon after the railroad reaches Denver." (CC.)

MINERAL ANALYSIS. General Palmer returned to Colorado City in July 1869 looking for a route for his railroad. When he arrived, the price of Soda Springs was up to $26,000. Palmer's Colorado Springs Company bought the springs. Buildings were constructed, the springs were encased in iron pipe, and water was piped directly into bottles, which were distributed and sold in Denver and Pueblo. (MSHC, Anna Galbreaith.)

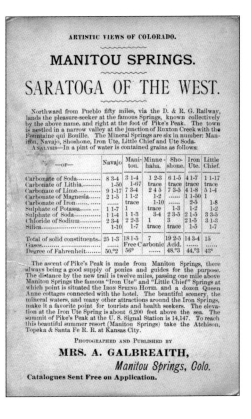

ARTISTIC VIEWS OF COLORADO.

MANITOU SPRINGS.

SARATOGA OF THE WEST.

Northward from Pueblo fifty miles, via the D. & R. G. Railway, lands the pleasure-seeker at the famous Springs, known collectively by the above name, and right at the foot of Pike's Peak. The town is nestled in a narrow valley at the junction of Ruxton Creek with the Fountaine qui Bouille. The Mineral Springs are six in number: Manitou, Navajo, Shoshone, Iron Ute, Little Chief and Ute Soda.

ANALYSIS—In a pint of water is contained grains as follows:

—or—	Navajo	Manitou.	Minnehaha.	Shoshone.	Iron Ute.	Little Chief.
Carbonate of Soda	8 3-4	3 1-4	1 2-3	6 1-5	4 1-7	1 1-17
Carbonate of Lithia	1-50	1-67	trace	trace	trace	trace
Carbonate of Lime	9 1-17	7 3-4	2 4 5	7 3-5	4 1-8	5 1-4
Carbonate of Magnesia	2 1-5	1 1-2	1-2	1 1-50	1
Carbonate of Iron	trace	1-10	2-5	1-8
Sulphate of Potassa	1 1-7	1	trace	1-3	1-2	1-2
Sulphate of Soda	1 1-4	1 1-3	3-4	2 3-5	2 1-5	3 3-5
Chloride of Sodium	2 3-4	2 2-3	1	3	2 1-5	3 1-3
Silica	1-10	1-7	trace	trace	1-5	1-7
Total of solid constituents	25 1-3	18 1-5	7	19 2-5	14 3-4	15
Gases	Free Carbonic Acid.		
Degree of Fahrenheit	50.°2	56°	48.°3	44.°3	43°

The ascent of Pike's Peak is made from Manitou Springs, there always being a good supply of ponies and guides for the purpose. The distance by the new trail is twelve miles, passing one mile above Manitou Springs the famous "Iron Ute" and "Little Chief" Springs at which point is situated the IRON SPRING HOTEL and a dozen Queen Anne cottages connected with the hotel. The beautiful scenery, the mineral waters, and many other attractions around the Iron Springs, make it a favorite point for tourists and health seekers. The elevation at the Iron Ute Spring is about 6,200 feet above the sea. The summit of Pike's Peak at the U. S. Signal Station is 14,147. To reach this beautiful summer resort (Manitou Springs) take the Atchison, Topeka & Santa Fe R. R. at Kansas City.

PHOTOGRAPHED AND PUBLISHED BY

MRS. A. GALBREAITH,

Manitou Springs, Colo.

Catalogues Sent Free on Application.

WILLIAM C. BELL. On another visit, General Palmer wrote, "On Cherry Creek, October 21st [1869]. Yesterday we came hither from Colorado City. The whole party was in the finest humor. Pikes Peak never looked grander, and the Garden of the Gods fascinated my companions of the Eastern frontier so that they bubbled all over with enthusiasm, resembling the Soda Springs, from which we drank great quaffs, as Dr. Bell and I had done only a month before." (CC.)

QUEEN PALMER. On a tour to select the site for Colorado Springs in the spring of 1870, General Palmer, Queen Mellen, and others were visiting the area. Irving Howbert accompanied the party to the Soda Springs, the Garden of the Gods, and other places of interest. Palmer was trying to convince his fiancée that she could be happy living in the Pikes Peak region. (CC.)

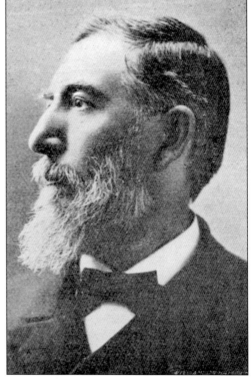

WILLIAM E. PABOR. In 1871, Palmer hired William E. Pabor to publicize the attractions around his new development of Colorado Springs, planned as a resort city on the Denver & Rio Grande Western Railroad. (CC.)

SIAMESE TWINS. William E. Pabor, secretary of General Palmer's Colorado Springs Company, in his effort to attract people to the area, described the formations in the Garden of the Gods in exotic terms. Palmer was not amused and asked Pabor to resign (MSHC.)

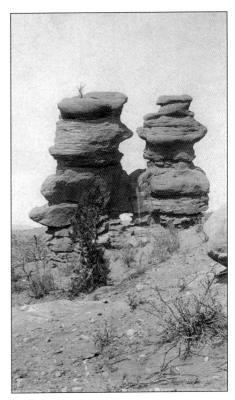

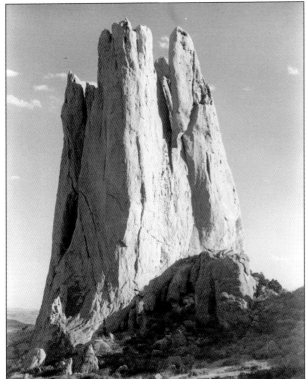

TOWER OF BABEL. According to Earl Pomeroy in *In Search of the Golden West*, "The rock formations rather significantly known as the Garden of the Gods, near Colorado Springs, had a typical and dependable appeal, despite the misgivings of some old-fashioned spirits who felt that 'something less heathenish (for a name) would better have befitted these Christian days.' " (CC.)

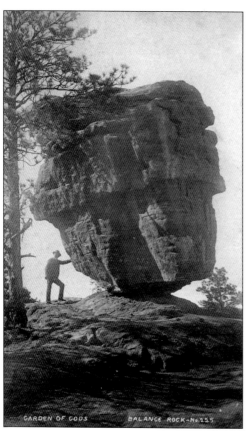

HOLDING UP BALANCED ROCK. In some respects, the rocks represented the extremity of interest in the grotesque. "No other point of interest," boasted the Denver & Rio Grande Western Railroad, "is more unique or more to be admired than this curious freak of nature." (MSHC.)

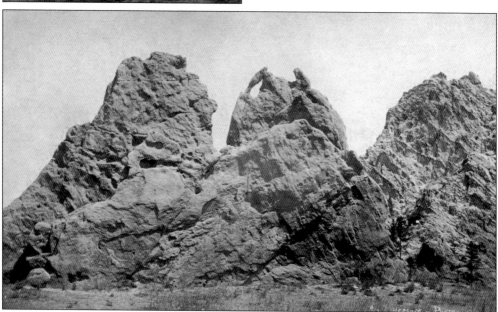

SEAL MAKING LOVE TO NUN. Earl Pomeroy goes on, "[The Garden's] admirers thought that they saw a stag's head, curious birds and crawling serpents, an eagle with pinions spread, a seal making love to a nun, and an elephant attacking a lion, among other grotesque and picturesque sights." (MSHC.)

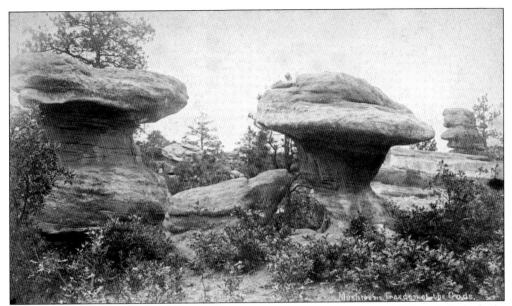

TOAD AND TOADSTOOL. According to Earl Pomeroy, one visitor complained, "There is little doubt that the average tourist is so intent on finding these monstrosities, that he miss the grandeur and glory of the place." (MSHC, Hook.)

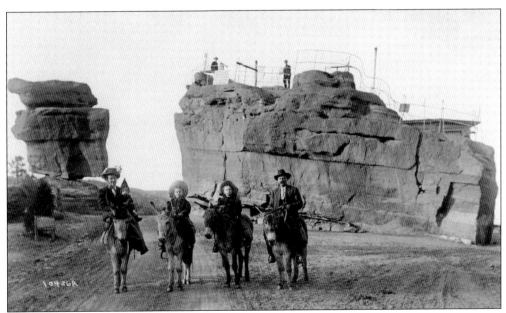

STEAMSHIP ROCK. In another passage from Pomeroy, "The tourist saw the Old World as well. He might pass under the shadow of China's great wall, muse among Palmyra's shattered and fallen columns, stand face to face with the mysterious Sphynx of Egypt, gaze upon the Temples of Greece, or the Castles of England and Germany, or the old Abbeys which pious monks upreared." (MSHC.)

Prof. James Huchison Kerr. Professor Kerr moved to Colorado Springs in 1874 to cure his tuberculosis. In 1875, Kerr became the professor of assaying, geology, mining, metallurgy, and chemistry at Colorado College and served as acting president from 1885 to 1889. In 1878, Professor Kerr "discovered in one of the ridges east of the red rocks forming the east boundary of the Garden of the Gods portions of 21 different sea monsters that had been caught in a basin in one of Earth's early paroxysms." Of the animals, one was estimated to be 117 feet long and of the Cretaceous period. The bones were stored in boxes that were placed in barns and cellars around the college. Nearly all were subsequently lost. A Camptosaurus skull was taken to Yale Peabody Museum, stored away, and forgotten for 110 years. (CC.)

PUNCH BOWL. In 1877, Isabella Bird, author of *A Lady's Life in the Rocky Mountains*, rode through Glen Eyrie and the Garden of the Gods and wrote, "I then came to strange gorges with wonderful upright rocks of all shapes and colours, and turning through a gate of rock, I came upon what I knew must be Glen Eyrie, as wild and romantic a glen as imagination ever pictured." (PPLD, Chamberlain.)

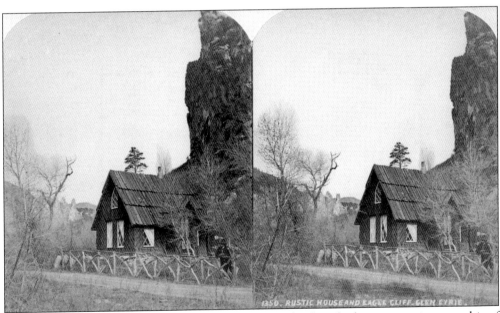

RUSTIC HOUSE AND EAGLE CLIFF, GLEN EYRIE. General Palmer had no interest in ownership of the Garden of the Gods because it had no water. Instead, he chose Glen Eyrie, so named because of the eagles' nest on the great gray entrance rock. Palmer named the canyon to the west Queen's Canyon after his wife. (PPLD.)

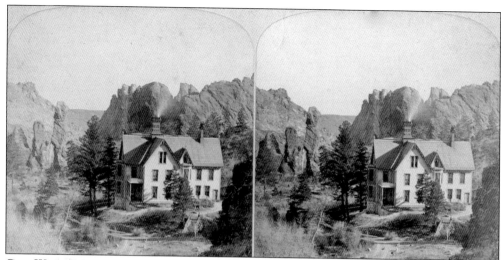

GEN. WILLIAM J. PALMER RESIDENCE (ABOVE) AND GLEN EYRIE HALL. Isabella Bird and her hosts paid a visit to General Palmer at Glen Eyrie. "After lunch, . . . [we] left Colorado Springs, crossing the mesa, with a view of extraordinary laminated rocks, leaves of rock a bright vermilion colour, against a background of snowy mountains, surmounted by Pikes Peak. Then we plunged into cavernous Glen Eyrie, with its fantastic needles of colored rock, and were entertained at General Palmer's 'baronial mansion,' a perfect eyrie, the fine hall filled with buffalo, elk, and deer heads, skins of wild animals, stuffed birds, bear robes, and numerous Indian and other weapons and trophies. Then through a gate of huge red rocks, we passed into the valley, called fantastically, Garden of the Gods, in which, were I a divinity, I certainly would not choose to dwell." (Both, PPLD.)

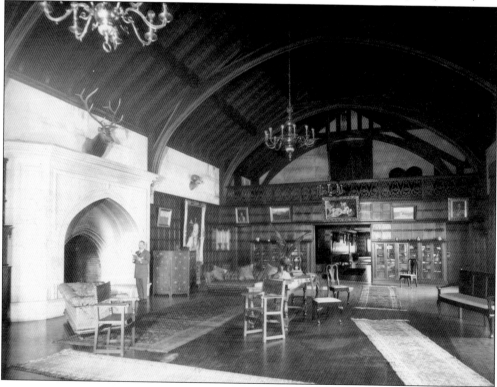

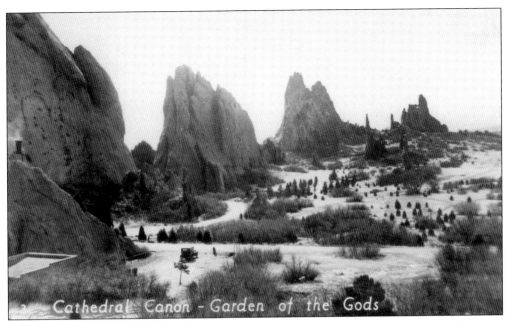

Cathedral Canon - Garden of the Gods

CATHEDRAL CANYON. Ernest Ingersoll wrote in *The Crest of the Continent*, "Garden of the Gods [is] hidden behind those garish walls of red and yellow sandstone, so stark and out of place in the soberly-toned landscape that they travesty nature, converting the whole picture into a theatrical scene, and a highly spectacular one at that. Passing behind these sensational walls, one is not surprised to find a sort of gigantic peep-show in Pantomime." (MSHC.)

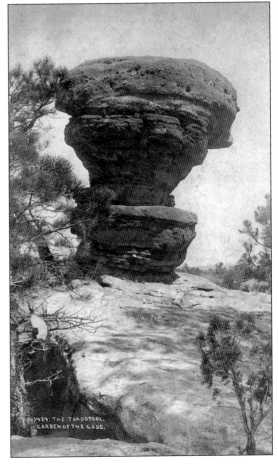

TOADSTOOL. Julian Street wrote of his 1919 visit to the Garden of the Gods in *Abroad at Home*: "The place irritated me. For if ever any spot was outrageously over named, it is that one. . . . [A]s a natural wonder in the Rocky Mountains, with Pikes Peak hanging overhead, it is a pale pink joke. . . . [T]he name is too fine to waste, and a thousand spots in Colorado are more worthy of it." (MSHC, Davis.)

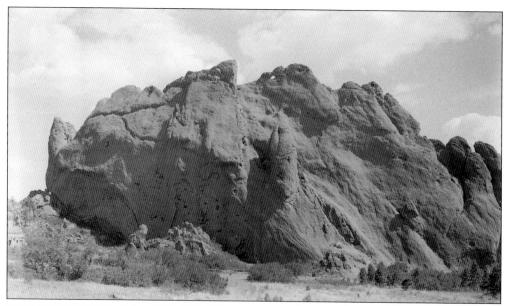

KISSING CAMELS (ABOVE) AND
SCOTSMAN. Julian Street goes on,
"Guides will take you through, and
they will do their utmost, . . . to make
you imagine that you are really seeing
something. They will point out inane
formations in the sandstone rock, and
will attempt to make you see that these
are 'pictures.' They will show you the
Kissing Camels, the Bear and Seal,
the Buffalo, the Bride and Groom,
the Preacher, the Scotsman, Punch
and Judy, the Washerwoman, and
other rock forms, sculptured by Nature
into shapes more or less suggesting
the various objects mentioned."
(Above, PPLD, Zelley; left, MSHC.)

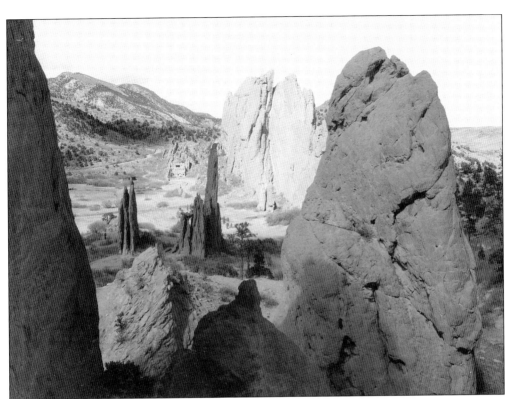

INNER GARDEN. On a journey from Denver to Colorado City, Albert D. Richardson and his companions passed unusual red rock formations on the way south, culminating in the towering gateway to the Garden of the Gods. They spoke of eagles building their nests on the summit. "Through this natural gateway we passed into a large enclosure walled in by mountains on every side—indeed a garden for the gods." (CSPM.)

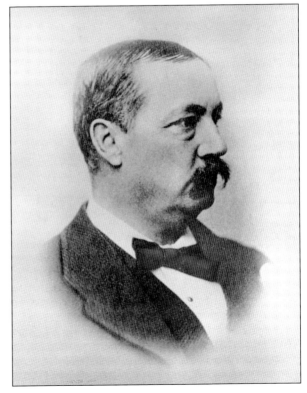

CHARLES E. PERKINS. General Palmer urged his friend Charles Perkins to build a home in the Garden of the Gods and to bring his railroad, the Burlington, to Colorado Springs. In 1879, Perkins bought 480 acres for $10,473. He never built the home, and the Burlington never reached Colorado Springs. Perkins left the management of the property to Henry Wills who kept it open and free for all visitors. (CC.)

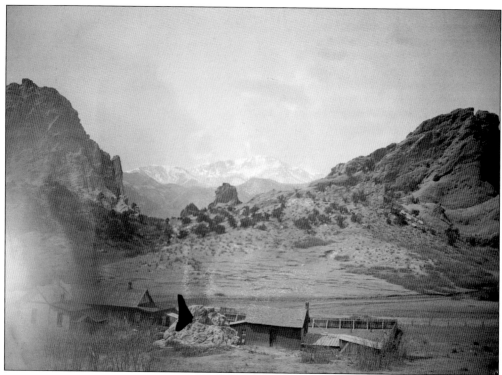

BALANCED ROCK MINE. Charles Perkins's purchase was not enough to protect the Garden of the Gods from various entrepreneurs. In 1879, a gypsum quarry was located on the back side of White Rock. A trench-like scar is still visible today. (DPL, Poley.)

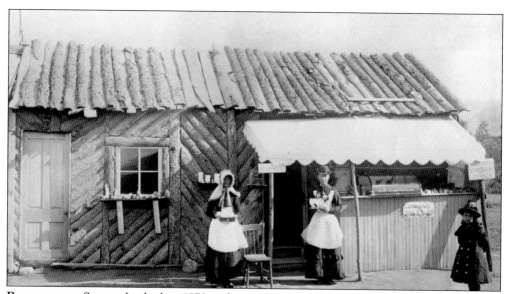

REFRESHMENT STAND. In the late 1870s, a lager saloon was built under the image of the kissing camels, and Billy Bryan built a stairway to the top of Gateway Rock in March 1883. By July, he had opened a nearby resort and celebrated the Fourth of July with fireworks and a moonlight dance. (PPLD.)

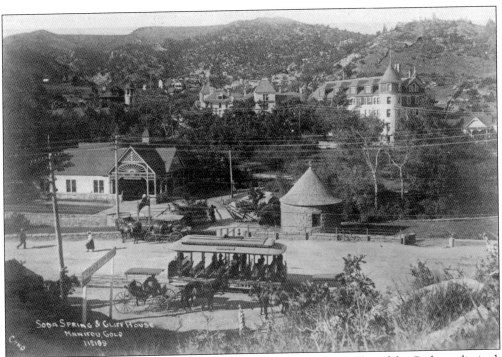

EL PASO RAPID TRANSIT AT SODA SPRINGS. Transportation to the Garden of the Gods was limited, so some entrepreneurs and speculators developed plans to remedy the situation. In 1889, the El Paso Rapid Transit Company was incorporated. They obtained franchises to run horsecars to the Garden of the Gods as well as to Austin Bluffs, Colorado City, Manitou, Cheyenne Canyon, and other points of interest. (MSHC.)

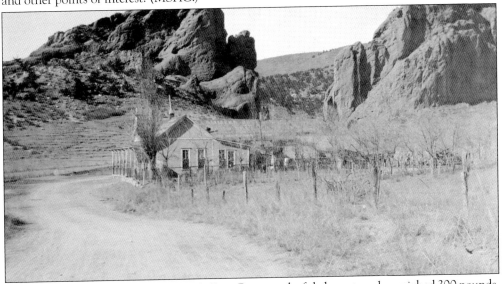

FATTY RICE'S EMPORIUM. In 1892–1898, Fatty Rice, a colorful character who weighed 300 pounds, acquired six corner lots in the newly platted Garden City development a block or so east of the Gateway Rocks. Here, Fatty established an emporium where he sold liquid refreshments "of the strong type," food, and curios to all who came, whether by horse, carriage, hiking, or cycling up over the mesa. (CSPM.)

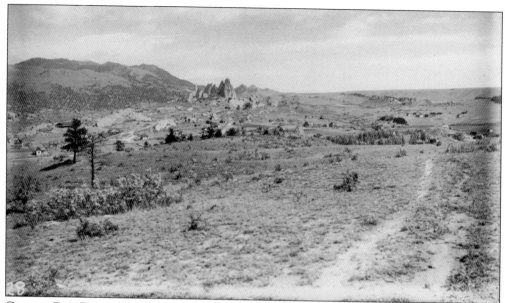

GARDEN CITY DEVELOPMENT. Palmer and Perkins felt that Fatty's place, even though outside the Garden of the Gods proper, distracted attention from the "dignity and beauty of the surroundings." In 1907, Palmer, who had earlier purchased many of the Garden City lots as a buffer zone for the Garden of the Gods, including his 1900 purchase of the Chambers Ranch, purchased the property from Fatty's widow. (CC.)

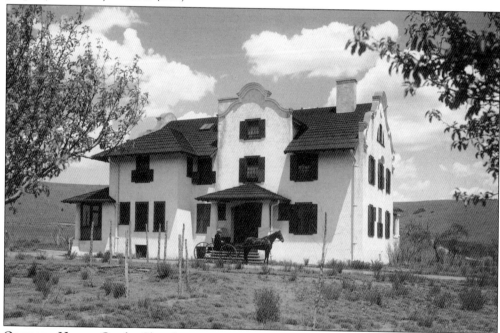

ORCHARD HOUSE. On the Chambers property, Palmer built the Orchard House, later called the White House, for his wife's half sister Charlotte Schlater. The property became part of the city park system as White House Ranch Historic Site. Now called the Rock Ledge Ranch Historic Site, it consists of the 1868 Galloway House, the 1895 Chambers Rock Ledge Farm, and the 1907 Orchard house. (PPLD, Standley.)

90

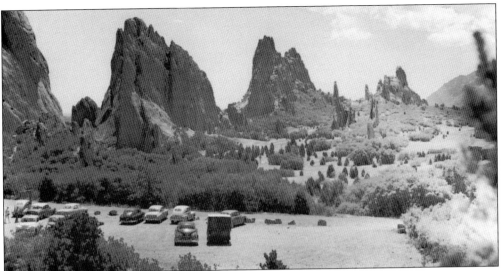

GARDEN ZONE. On March 8, 1886, a bill (H.R. 6580) was introduced into Congress proposing a Garden of the Gods National Park. It was to be 30 miles square, including Pikes Peak, Colorado Springs, Colorado City, Manitou Springs, Cripple Creek, and Victor. A comment in the newspaper stated that the Garden of the Gods was private property and seemed beyond the power of the government to acquire it. (OCCHS.)

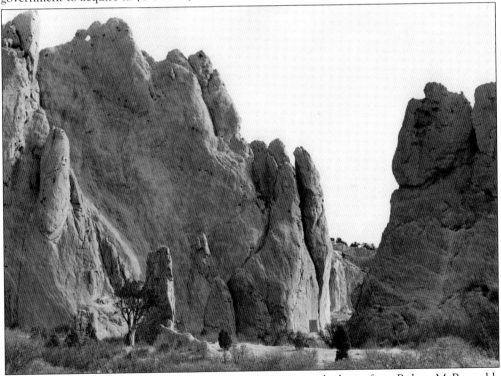

GATEWAY FROM THE WEST. On April 3, 1903, Palmer received a letter from Robert McReynolds of Colorado City suggesting it would be a good idea to carve busts of some the presidents in the giant peaks in the Garden of the Gods. General Palmer replied that he felt it would not be in good taste to mutilate the scenery. (South Dakota's Mount Rushmore was completed in 1927.) (CC.)

91

GENERAL PALMER, HORSEMAN. On October 27, 1906, a few weeks after General Palmer's 70th birthday, the general and his daughters Dorothy and Marjory and a friend had been horseback riding in the Garden of the Gods. They were headed home when just a mile or two from Glen Eyrie, the general's horse stepped on a rock and stumbled. Palmer fell and landed on his head on the road. The fall had broken his neck in three places and injured his spinal cord. He could only control his head and neck freely, move his shoulders, and bend his elbows slightly. Palmer lived three more years and then passed away in his home at Glen Eyrie at the age of 72. General Palmer's and Charles Perkins's dream of preserving the Garden of the Gods for the free use of everyone has lived on, and millions of people from all over the world have benefited from their generosity. (CC.)

Six

CITY PARK
A FREE PLACE TO PLAY

The Garden of the Gods was turned over to three trustees by Charles Perkins's six children two years after his death until the legal transfer to Colorado Springs could be completed. A few days before 1909, the Colorado Springs City Council voted to accept the gift. A formal ceremony of acceptance was held on October 3, 1912.

During the early days, students from Colorado College went dancing and picnicking in the moonlight in the Garden of the Gods. Other uses of the garden have included civic gatherings, footraces, rock climbing, and weddings. Horseback riders, hikers, and mountain bikers have also found the Garden of the Gods a special place to practice their sports. In the 1940s, it was a favorite stopover for recruits on their way to war and became a favorite haunt for the flower children of the 1960s. The local American Indian population continues to use the Garden of the Gods for religious purposes.

Attracting over a million visitors a year, the Garden of the Gods began to show wear and tear. A Garden of the Gods master plan for preservation was completed in 1994. Areas to be improved were the trail system, traffic in the park, and regulation of activities that damage the ecosystem. Another issue addressed in the master plan was the need for a new visitor center, which is now located just east of the park.

Today, a visitor walking through the Garden of the Gods finds vistas neither impaired by buildings nor crisscrossed by roads and paths. The more vulnerable areas are protected from the damage done by thousands of visitors' feet trampling on the delicate vegetation, or from being torn up by overly enthusiastic mountain bikers or horseback riders. Visitors may tour the park with a park interpreter, helping them to understand the special nature of the Garden of the Gods. Thanks to the master plan and its protection as a city park, millions more visitors will be able to enjoy the special nature of the Garden of the Gods.

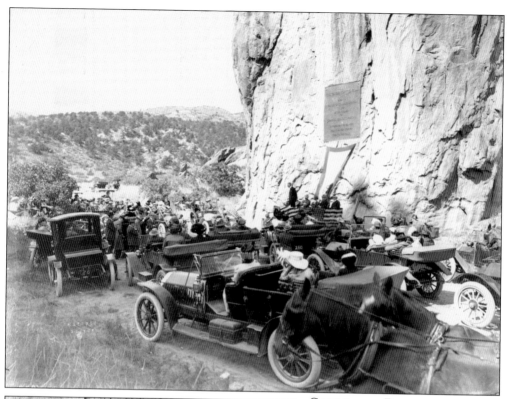

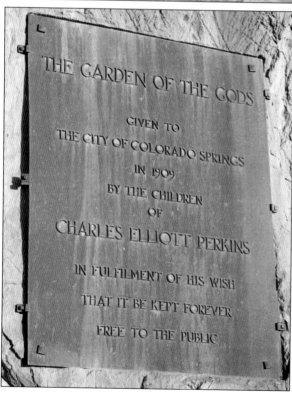

CEREMONY OF DEDICATION AND PERKINS'S PLAQUE. Charles Perkins died in November 1907. Perkins scribbled on an old envelope his desire to give the Garden of the Gods to the city of Colorado Springs. On December 25, 1909, the *Gazette* announced the gift: "When Colorado Springs awakes this morning, it will find in its stocking the biggest Christmas gift in the history of the city—the famed Garden of the Gods. . . . This marvelous park, which is known throughout the United States and to many foreign lands for its curious rock formations, today becomes the property of Colorado Springs. . . . The ordinance under which the gift was accepted . . . bars the sale and manufacture of any intoxicating liquor on the property. The erection of buildings except those deemed absolutely necessary for park purposes is also prohibited." (Above, CSPM; left, CC.)

PAUL GOERKE. For over 35 years, Goerke and Son carried on a very popular photography business centered around Balanced Rock, which they had developed on the western edge of the Garden of the Gods. (PM, Goerke.)

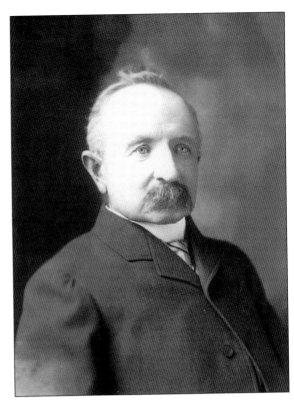

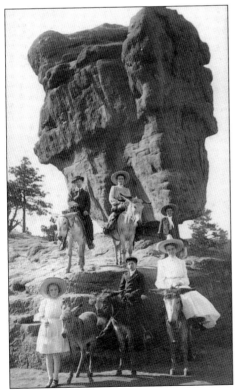

BALANCED ROCK AND BURROS. The early Goerke photographs were of people sitting astride or standing beside little burros in front of the south side of Balanced Rock. Photography subjects were also requested to wear the big hats that Goerke provided. (MSHC, Goerke.)

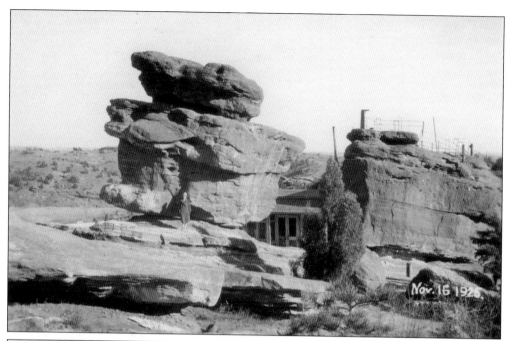

Nov. 15 1928

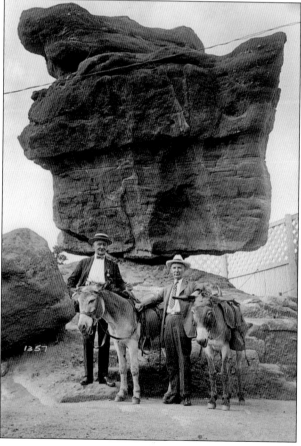

GOERKE'S PHOTOGRAPHY BUSINESS. Goerke's Photography shop was nestled between Balanced Rock and Steamship Rock. They added the railings and telescopes to the top of Steamship Rock to make it look more like a ship. Visitors could climb up and view the scenery through the telescopes. (OCCHS, Goerke.)

A FENCE AROUND BALANCED ROCK. After the Kodak camera came into popular use, young Goerke built a high board fence around Balanced Rock and charged 25¢ admission. (CSPM)

CURT GOERKE. In January 1923, after much controversy, Colorado Springs paid Curt Goerke $25,000 for 275 acres, including Mushroom Park, Balanced Rock, and Steamboat Rock. This land was among the earliest additions to the Garden of the Gods. (CSPM, Goerke.)

PUBLIC TOURING CARS IN THE GARDEN. The Garden of the Gods had become such a popular place that certain people felt better transportation was needed into and around the park. On April 25, 1913, the Colorado Springs Boosters Association advocated the construction of an electric line to the eastern terminus of the park. (CSPM.)

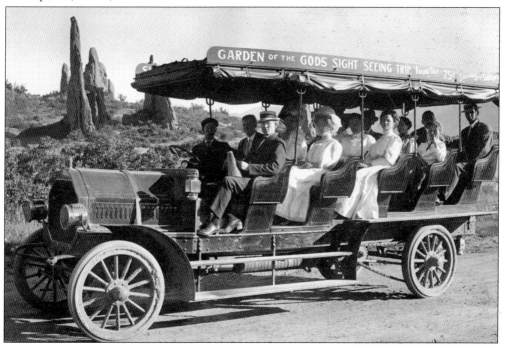

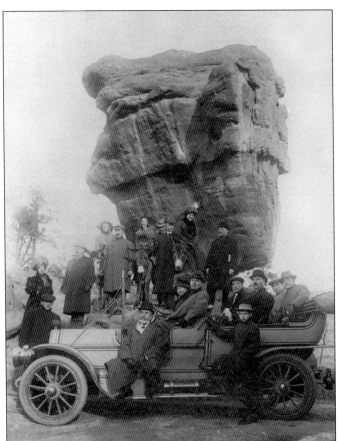

MODERN TOURISTS. The electric line to the eastern terminus never happened because automobiles made it easier to reach the Garden of the Gods. This apparently affluent group with their early-1900s touring car was photographed by the Goerkes. (MSHC, Goerke.)

FAMILY PICNIC. The Garden of the Gods has long been a favorite place for picnics, games, and festivals. Daytime picnics for young people included games like one called "snake scramble." Young ladies scrambled through the scrub oak, and when they saw a rattlesnake, they had to scramble back to their starting place. The last girl in had to kiss somebody. (PPLD.)

AMATEUR RODEO. The 1910s brought an economic slump to Colorado Springs. To offset this slump, some residents sought to draw tourist trade by staging a historical pageant about Indians and the 16th-century activities of the conquistadors in New Mexico and of old King Tartarax of Quivera. This pageant culminated in an amateur rodeo at the Garden of the Gods. (OCCHS.)

RODEO CONTESTANTS. This line of horsemen were contestants in the 1912 rodeo. Clarence Shemwell is in the dark shirt in the center of the photograph. His father, William, is on his right. (PPLD.)

FLOWER CARNIVAL ENTRY. The 1911 celebration was marked by a parade of 200 floats decorated with flowers, bands, five volunteer fire departments, a masked ball, and an aviation event, featuring a biplane flown in for the occasion. (PPLD.)

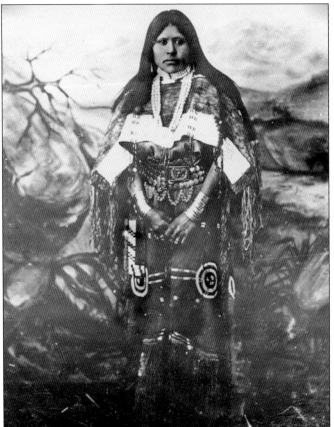

CHIPETA, WIFE OF OURAY. A group of Ute Indians from the Ute Reservation in Ignacio, Colorado, were invited to take part in the carnival. Chipeta, wife of the famous Chief Ouray, and Chief Buckskin Charley, two notable leaders of the Ute tribe, accompanied the group. (PPLD, Poley.)

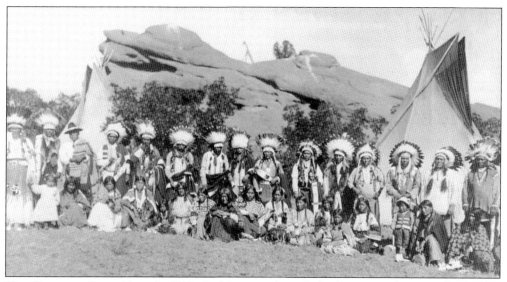

UTE CHIEFS AT SHAN KIVE. In 1912, the Utes were brought back again to dance in the Garden of the Gods and place offerings in the springs at Manitou, as their ancestors had for generations. Spectators were able to see Indian life and customs under what was advertised as normal tribal conditions. The Ute Indians were the major attraction, and the celebration was named Shan Kive. (PPLD, Stewarts.)

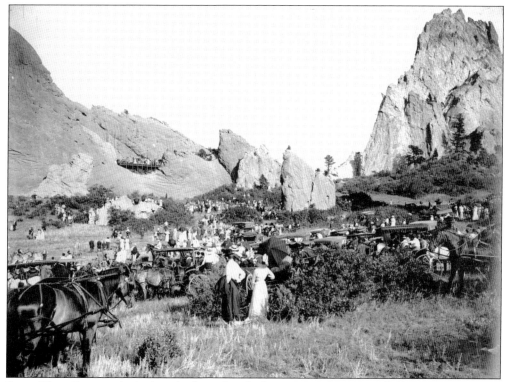

SHAN KIVE CROWD. A platform built on South Gateway Rock permitted all to see the Indians perform traditional dances. The Indians came into view in single file over the top of a steep, narrow, winding trail that began at the extreme southern end of the rock. (PPLD, Stewarts.)

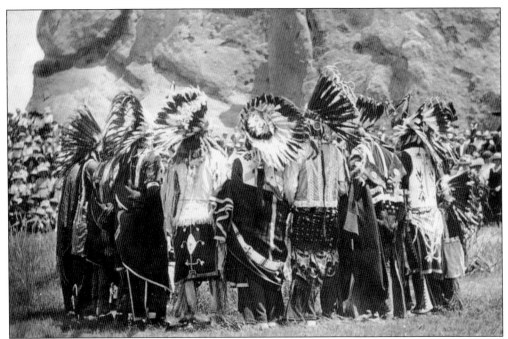

UTE DANCE. Accompanied by tom-toms and their own singing, the men and women put on their Sun-Moon Dance, followed by their Harvest Dance and others. (PPLD, Poley.)

COMING DOWN OLD UTE TRAIL. The Indians mounted horses in Cascade then rode down over the ancient Indian trail in the hills on the south slope of Ute Pass. The colorful procession started down the trail from Cascade toward Manitou. The braves wore their buckskin suits and feathered war bonnets, and the women were greatly adorned with turquoise and silver jewelry. The Indians needed no guides. (PPLD, Poley.)

BUCKSKIN CHARLEY COMING HOME. Buckskin Charlie, chief of this tribe, had not been over the trail since the Utes had left more than 30 years earlier. His birthplace was the Garden of the Gods, and he remembered every turn in this trail he had ridden since he was a boy. "I'm seventy years old," he said, "I never so happy in all my life." Marble markers were placed along the route. (PPLD, Poley.)

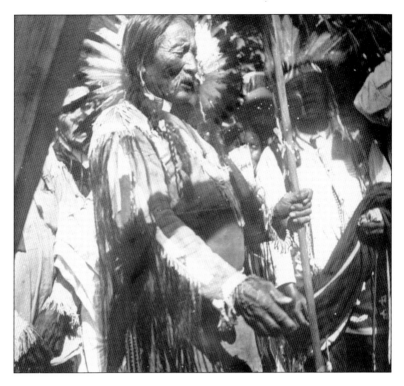

UTE TRAIL MARKER AT MANITOU SPRINGS. The main event of the 1912 celebration was the marking of the Ute Trail. Ceremonies were held at Soda Springs Park where dignitaries spoke to several thousand in the audience. A box containing historic mementos was placed under a boulder. (This box, in a much rusted condition, was opened in 1962 to reveal a soggy disintegrated pulp.) (PPLD, Poley.)

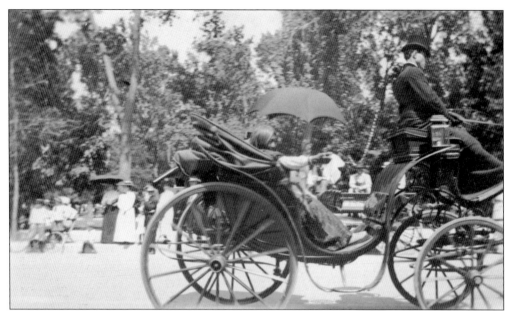

CHIPETA IN CARRIAGE. In 1913, the Indian camp was located near Adams Crossing (between Manitou and Colorado City where the red rocks opened into a natural amphitheater on private property). Buckskin Charlie and Chipeta were again the guests of honor. On the first day was a 10-mile footrace from the park through city streets to the Garden of the Gods. (MSHC.)

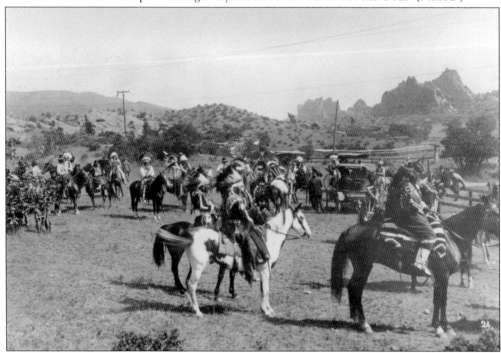

UTES AT CELEBRATION. A grand parade was featured on the second day when 30,000 spectators watched as 50 Utes, 300 cowboys, 700 pioneers, and Civil War veterans marched through downtown. The final two days had bucking bronco contests, footraces among the Indians, Ute dances in the garden, and a carnival in the streets. The festivities ended with a masquerade ball. (OCCHS.)

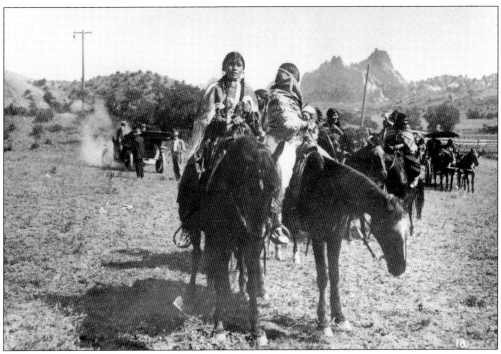

UTE GIRLS ON HORSEBACK. The 1913 celebration was the last visit by the Utes. The trip to Colorado Springs was too expensive and against Indian Agency rules because the event commercialized the Indians. The carnival continued without the Utes for more than a decade until the start of World War I. After 1920, the celebration evolved into the Pikes Peak or Bust Rodeo. (OCCHS.)

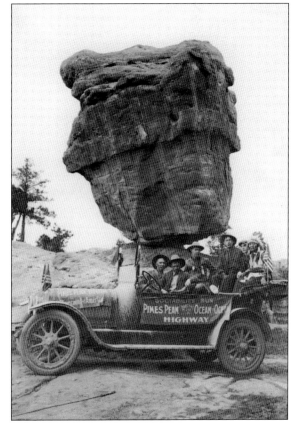

PIKES PEAK OCEAN-TO-OCEAN HIGHWAY. Begun in 1912, the Pikes Peak Ocean-to-Ocean Highway spanned the continent from New York City to Los Angeles in a time when paved roads were rare and traveling by car for more than 10 miles was an adventure. Avoiding big cities like Denver, the route ran through Colorado Springs, bringing visitors to Pikes Peak and the Garden of the Gods. (OCCHS.)

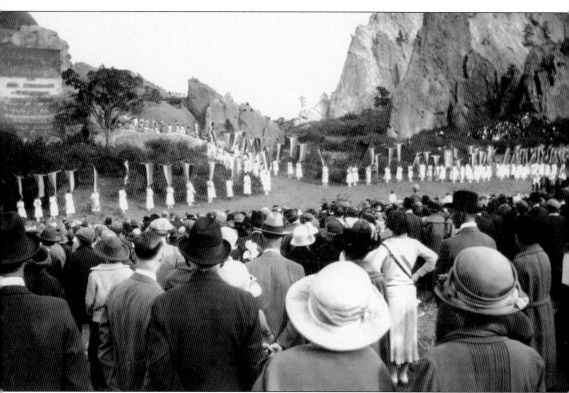

NATIONAL WOMAN'S PARTY PAGEANT. The National Woman's Party held their convention in the Garden of the Gods on September 23, 1923. Susan B. Anthony, Elizabeth Cady Stanton, and Lucretia Mott took part in a pageant at Pulpit Rock before what was reportedly the greatest crowd ever assembled in the Garden of the Gods. The pageant consisted of women in hoop skirts, pantalets, and poke bonnets as well as 24 young girls on horseback representing the youth of the Western world, which was to be the vanguard of the drive for the Equal Rights Amendment to the federal constitution drafted by Alice Paul. An enthusiastic appeal for support of Western women in the forthcoming congressional campaign was made by Alva Belmont, president of the National Woman's Party. (PPLD.)

CIVILIAN CONSERVATION CORPS (CCC) WORKERS. During the early 20th century, the cavern in North Gateway Rock had been forgotten, and the mouth became filled with weeds and debris until 1935 when an old man who had played there as a child insisted upon the reopening of the cave. The cave was found and reopened. The names *A.S. Voorhees* as well as those of several other early pioneers were still visible. (PPLD.)

YOUNG JUNIPERS. The CCC carted out 175 loads of dirt and cut steps in the cavern floor. However, falling rock prevented the cave from opening to the public. The cavern was permanently sealed with concrete and iron bars. In 1935, the CCC also planted several thousand junipers and obliterated a number of dirt roads that marred the beauty of the Garden of the Gods. (OCCHS.)

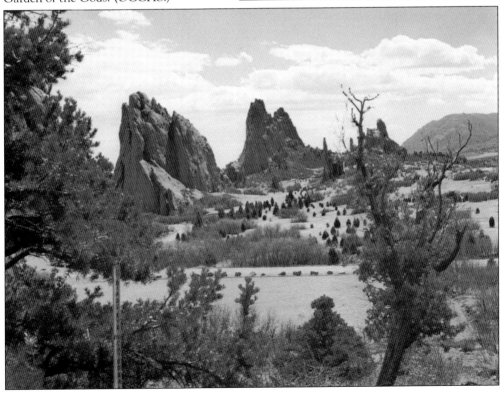

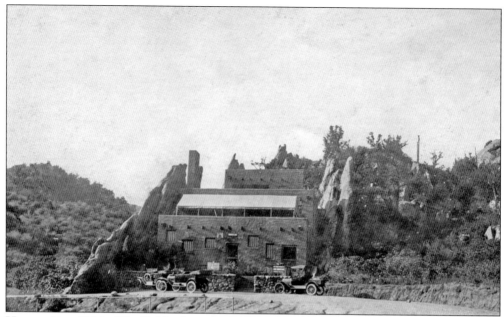

HIDDEN INN, 1920s. The Hidden Inn, the first building in the Garden of the Gods, was located west of North Gateway Rock and nestled between two 50-foot sandstone wings. A pueblo-style building designed by Carl Balcomb, it was constructed in 1915 by Colorado Springs architect Thomas P. Barber. It was designed as a curio shop and tearoom offering souvenirs, food, and drink, but no intoxicating liquors. (MSHC.)

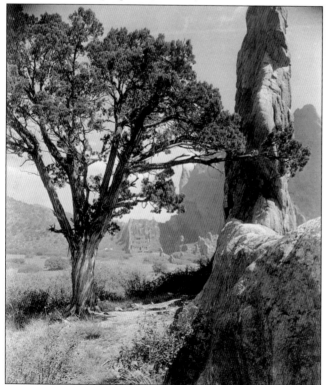

HIDDEN INN VISTA. The inn also served as living quarters for the caretaker of the park. Visitors to the park could find refuge here during storms, browse through the souvenirs, enjoy a snack, or look out at the sky and red rocks from the rooftop terraces. This building was a fine example of early pueblo architecture, being based on the early Indian adobe houses and the Taos Indian Pueblo. (CC.)

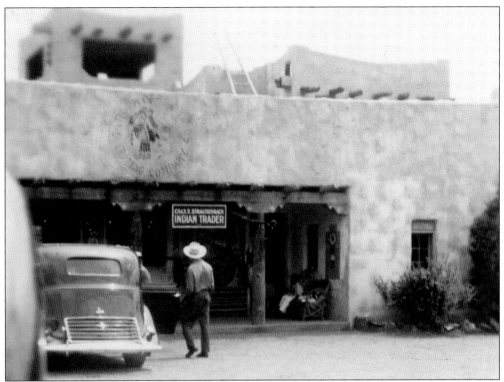

GARDEN OF THE GODS TRADING POST, 1920s. The Trading Post was built on the south edge of the Garden of the Gods in the early 1920s by Charles Strausenback to resemble the homes of the Pueblo Indians. (MSHC.)

TRADING POST, 2011. The Trading Post has expanded six times to become Colorado's largest art gallery and gift shop. The Hidden Inn and the Trading Post were the only structures not demolished when the property was taken over by the city. (AC, Evans.)

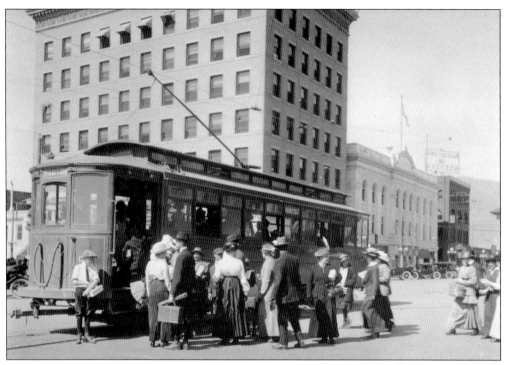

STARTING ON GARDEN OF THE GODS TRIP. Groups of people rode the streetcar to Manitou, then walked into the Garden of the Gods for picnics, carrying their hampers. During the early days, students from Colorado College also went dancing and picnicking in the moonlight in the Garden of the Gods. (PPLD, Standley.)

WOMEN ON ROCKS. Other uses of the Garden of the Gods have included civic gatherings, footraces, rock climbing exhibitions, and weddings. Horseback riders, hikers, and bicyclists have also enjoyed the trails in the park. (CC.)

A Soldier's View. In the 1940s, soldiers and airmen from the nearby bases frequently visited the Garden of the Gods before and after going overseas. The stagecoach was used to take tours through the garden because gas was rationed. (MSHC.)

Reverend Luce. As the Reverend Albert W. Luce, of the Pike's Peak Christian Church, was sitting at the foot of Cathedral Spires reading his Bible one day, the words of John 19:41 had special meaning. "Now in the place where he was crucified there was a garden: and in the garden a new sepulcher, wherein was never man yet laid. There laid they Jesus." (PPLD, Stewarts.)

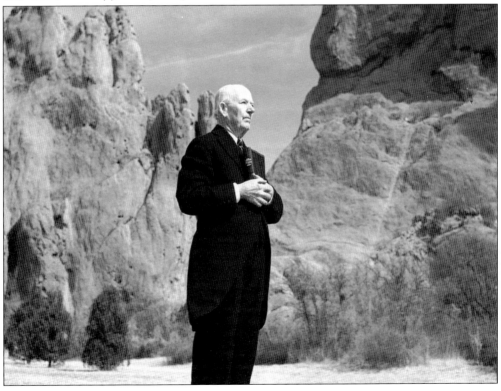

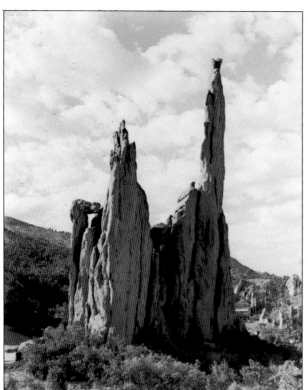

CATHEDRAL SPIRES. Drawing his inspiration from the Garden of the Gods, the thought came to Reverend Luce that this was a garden just like that mentioned in the Bible, and where would it be more appropriate to hold Easter service than in that which so nearly resembled the one at Gethsemane as he imagined it? (OCCHS.)

EASTER SUNRISE. Just before Easter 1919, he announced his plans for a sunrise Easter Service to his congregation. They were stunned. He went ahead with the service and was joined by about 700 people, most from his church, some from the First Christian Church. This interdenominational service became very popular with around 20,000–25,000 attending in 1950. (CC.)

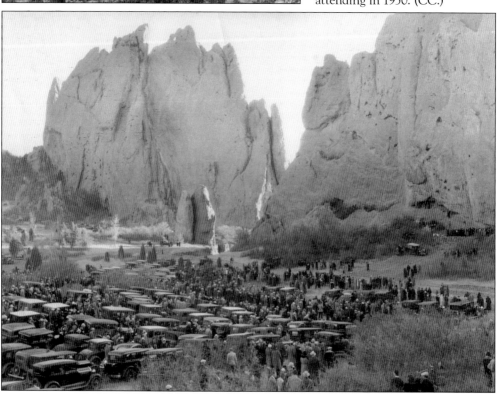

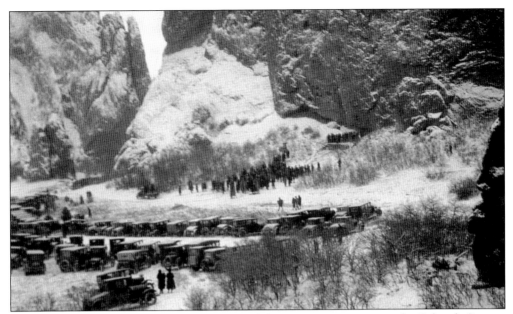

EASTER SUNRISE SERVICE. Reverend Luce turned the sunrise service over to the Colorado Springs Ministerial Alliance. All were invited to the service, and it was broadcast coast to coast over radio (Columbia Broadcasting System, the Armed Forces Network, and the Voice of America). By 1990, the numbers began dwindling, and the nationwide coverage stopped. After 70 years, the last service was held in 2002 to a crowd of 5,000. (OCCHS.)

CHUCK WAGON DINNERS. In 1935, the Colorado Springs Jaycees and their wives began hosting family-oriented chuck wagon dinners in the Garden of the Gods. The first was held for a group of eight visitors. Over the next three years, the dinners were held in different places in the park. Within those three years, the popularity had grown to the point where the dinners needed a permanent home. (PPLD, Stewarts.)

JANE RUSSELL. The area just east of North Gateway Rock became the permanent home of the chuck wagon dinners. Seating was limited to 700 to keep the dinners informal and so everyone could see the activities. The campfire would be lit by a flaming arrow "shot" off the top of one of the Gateway Rocks. Following dinner, wranglers would bring in a victim (a Jaycee or celebrity) for the branding scene. (PPLD, Stewarts.)

ROBERT MITCHUM. A white-hot branding iron was applied to the seat of the victim's jeans (protected by a board), and he would go running out through the crowd with a red-hot JC on his seat. Following the branding was entertainment put on by the wranglers in true Western style with lots of jokes and group singing. These dinners were an institution in the Garden of the Gods until the late 1970s. (PPLD, Stewarts.)

UTE TRAIL MARKER. In 1935, members of the Zebulon Pike and Kinnikinnik chapters of the Daughters of the American Revolution dedicated a stone marker for the Ute Trail in the Garden of the Gods. The trail, which runs behind the marker in this photograph, is used for hiking and mountain biking. (AC, Evans.)

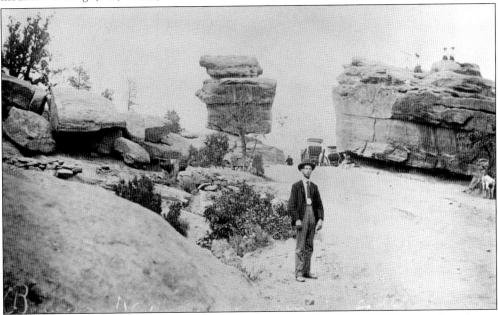

BALANCED ROCK, STEAMSHIP ROCK. A group of earth science students from Horace Mann Junior High School were browsing through the park one day in 1959 when two boys found a message hidden in a crevice under a rock a short way above Balanced Rock. The message was from a man named Charles Walscavage who had walked to the Garden of the Gods from Pennsylvania in 1924. (OCCHS.)

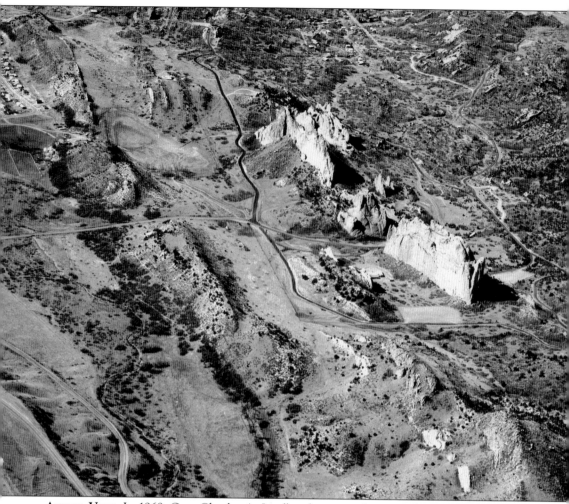

AERIAL VIEW. In 1968, Gen. Charles A. Lindbergh wrote a letter to the Garden of the Gods Preservation Council expressing his strong conviction that the surroundings of the unique Garden of the Gods should be protected from man-made encroachments. He included a gift of $100 to aid in its preservation. In the letter, the general reminisces about his visits to and flights over the Garden of the Gods: "The Garden of the Gods is one of the most beautiful and spectacular areas in the world. It would be a tragedy of major magnitude to lose, or to detract from, its great qualities—an inexcusable indifference on the part of our generation, and a lack of responsibility for those succeeding us. Barnstorming in Colorado, in 1925, I flew over and circled the Garden of the Gods; and laying out the transcontinental passenger airline in 1928–29, I often detoured . . . from my route to fly above it. . . . But my clearest memories came from earlier years when there was enough time to climb or circle." (PPLD, Stewarts.)

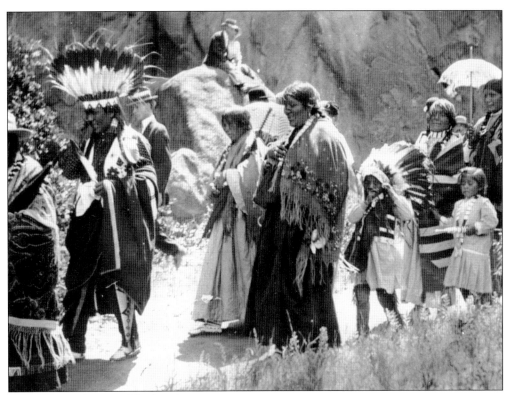

UTES IN THE GARDEN. The local American Indian population continues to use the Garden of the Gods for religious purposes. June 21, 1997, was the second annual World Peace and Prayer Day, a day for all Indian Nations to come together for the healing of Mother Earth. All Indian Nations were invited to attend this spiritual gathering. The participants sang, danced, and honored ancestors and Mother Earth. (PPLD, Poley.)

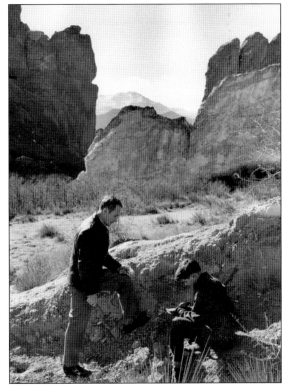

HUNTING FOSSILS. While doing research for the murals in the visitor center, Dr. Ken Carpenter, of the Denver Museum of Natural History, found out about Professor Kerr's forgotten dinosaur. The original Camptosaurus skull was brought back to Denver from Yale, and a cast was made and given to Colorado Springs. The replica was on exhibit for 10 years at the Garden of the Gods Visitor and Nature Center in the Jurassic exhibit. (CC.)

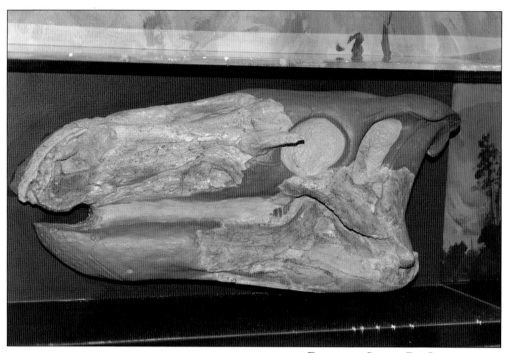

Dinosaur Skull. Dr. Carpenter and his colleague Kathleen Brill discovered the soil on the skull was actually from the Cretaceous period and noted several differences between this skull and a Camptosaurus. Carpenter and Brill named the creature *Theiophytalia kerri* and declared a new genus and species, named after the Garden of the Gods (*theios*, meaning "belonging to the gods," and *phytalia*, meaning "garden") and Professor Kerr (*kerri*). (AC, Evans.)

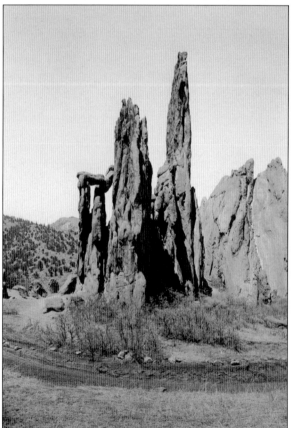

Erosion around Cathedral Spires. Attracting over a million visitors a year, the Garden of the Gods has begun to show the wear and tear of so much use. A master plan for preservation of the park was completed in 1976; however, by 1993 some of the issues of concern in 1976 were still unresolved, and new issues were being added to the list. (OCCHS.)

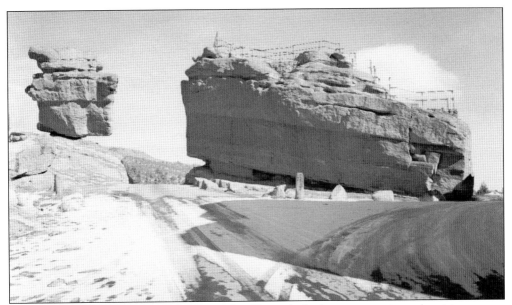

FENCE ATOP STEAMSHIP ROCK. The issues of traffic, rock climbing, concessions, the visitor center, erosion, and the trails still were not resolved, and the new issues of mountain bikes, signage, American Indian use, and accessibility were added. The guiding principle was, "Conservation, preservation, and restoration are overriding principles, and, within those principles, the ultimate aim is to allow activities in the park which will not conflict and which are appropriate to the setting." (OCCHS.)

TRAIL-USE SIGNAGE. The Trails Discussion Group recommended changes to the park trail system. The physical changes suggested included eliminating unnecessary trails and minimizing new trail development, only mapping designated trails, revegetating all other trails, adding needed signage indicating trail distance and destination as well as exact current location, improving identification of Ute Trail, and placing signs to tell which uses are allowed on each trail. (AC, Evans.)

PROTESTING VISITOR CENTER. In September 1993, Lyda Hill of Dallas, Texas, unveiled a proposal to build a new visitor center for the Garden of the Gods. The plan, which envisioned a $3.5-million complex on Thirtieth Street east of the park, was generally supported; however, some people were wary of it. (CC.)

VISITOR CENTER. The attractive, 12,600-square-foot building is tinted red to match the park's rock formations and blend in with the surrounding area. The new visitor center holds educational displays about the park's plants, animals, geology, and American Indian history. It also has a 3,000-square-foot gift shop, a 3,000-square-foot dining room and kitchen, an 80-seat theater that shows documentaries, and an observation terrace. (AC, Evans.)

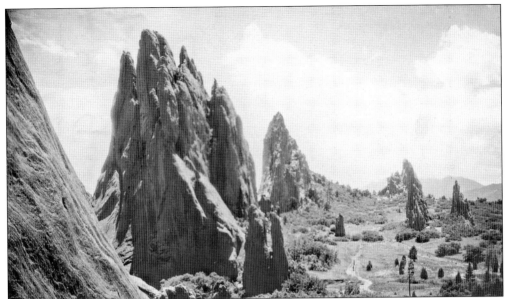

FROM HIDDEN INN. The Hidden Inn became a point of contention. Representatives of the Sierra Club felt the city should remove buildings from the park. They wanted most of the pavement near Hidden Inn torn up and the ground returned to a natural condition. Friends of Garden of the Gods said the Hidden Inn qualified as part of the park's history. Their goal was to use it as an education center. (MSHC.)

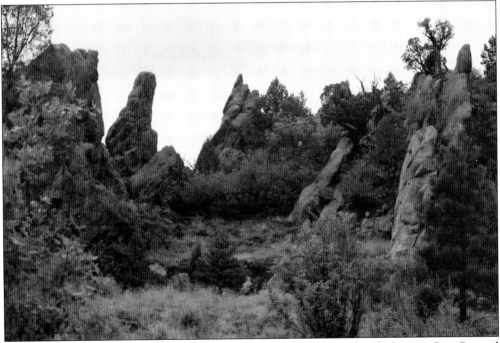

FORMER SITE OF HIDDEN INN. On Tuesday, August 26, 1997, the Colorado Springs City Council decided the building should be torn down and replaced with natural vegetation. Renovating the Hidden Inn to meet safety and accessibility codes would cost nearly $400,000. The final plan called for the building to be removed before the tourism season started in 1998. (AC, Evans.)

NEW SIGN. Tack Rice created signs for each entrance to the Garden of the Gods out of rock he selected from the Loukonen Brothers Stone Company quarry in Lyons, Colorado. The lettering was sandblasted into the rocks after the slabs had been secured in their cement bases. While Rice was working on the rocks, tourists asked him to move out of the way so they could get pictures. (AC, Evans.)

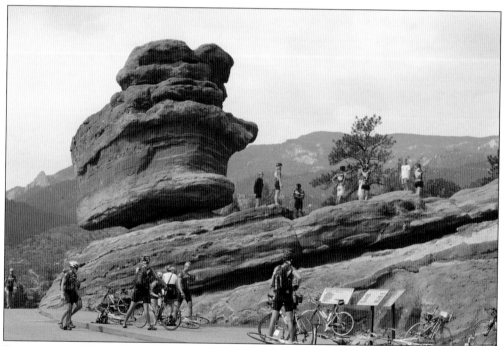

RIDING IN THE GARDEN. Bicycling of all kinds has become more popular in the Garden of the Gods since the traffic plan for on-street cycling and sanctioned trails for mountain biking has made it safer to practice both aspects of the sport. (AC, Evans.)

PROFESSIONAL CYCLING. Organizations that promote professional bike races are attracted to the Garden of the Gods. In August 2011, the route of the prologue of the inaugural USA Pro Cycling Challenge went through the Garden of the Gods. (CC.)

NEW, IMPROVED FOOTPATHS. Well-maintained paved paths in the Garden of the Gods have drawn more walkers and hikers to the park. People with disabilities are finally able to explore the inner garden area. (AC, Evans.)

RUNNERS IN THE GARDEN. Runners use the paved trails, the one-way roads, and the improved natural trail system to get their workouts. Organized road races are held in the Garden of the Gods annually. (AC, Evans.)

ROCK CLIMBERS. Climbing the rocks in the Garden of the Gods is as popular today as it ever was. Technical climbers must register with the visitor center, climb in groups of two or more, and use proper equipment. Even though all other climbing is illegal and will result in a $500 fine, a few people get stuck on the rocks each year and have to be rescued. (AC, Evans.)

HORSEBACK TOUR. Horseback riding is still permitted in the park, either by renting from a nearby stable, or trailering in with a horse. Access is restricted to designated equestrian trails that avoid the central Garden of the Gods area. (OCCHS.)

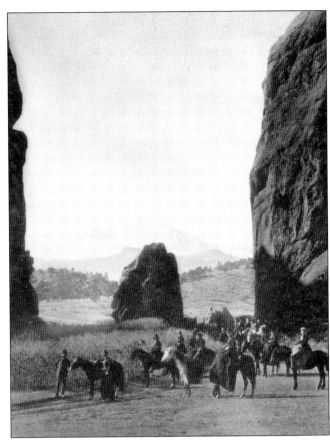

AUTOGRAPH ROCK, 2011. Even though signs are posted throughout the Garden of the Gods asking visitors to not carve their names into the rocks, the vandalism continues. The name and date of A.C. Wright have been badly damaged by modern visitors defacing the rock, as have many of the historic names. (AC, Evans.)

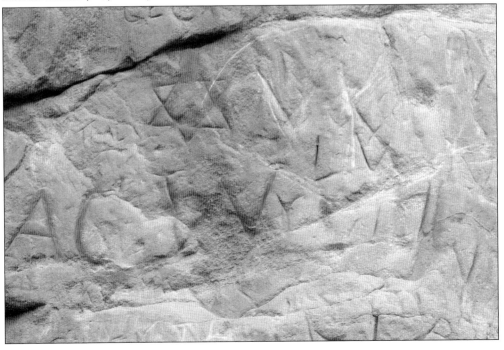

EROSION. The valley between Sleeping Giant and Cathedral Rock was badly eroded as water from heavy rains roared down an unimproved foot trail. A number of ancient hearths were in this valley and are gone now. (AC, Evans.)

EFFECTS OF WIND AND WEATHER. The Garden of the Gods continues to evolve through the natural process of erosion. Revegetation and the removal of trails have slowed down the process, but the rock formations are at the mercy of the elements. The seal portion of the Bear and the Seal broke off in 1941. (AC, Evans.)

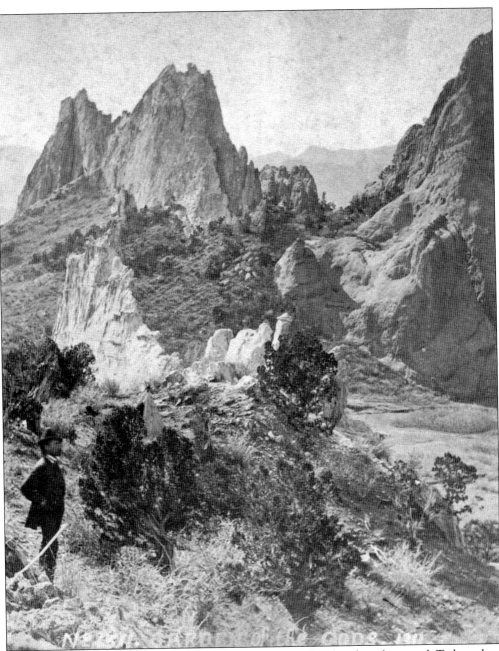

THE UNSPOILED GARDEN. The master plan has been completed and implemented. Today, when a visitor walks through the Garden of the Gods, he finds vistas neither impaired by buildings nor crisscrossed by roads and paths. The newly planted vegetation is taking hold, and the area looks more natural than it has in the recent past. The more vulnerable areas are protected from the damage done by thousands of visitors' feet trampling on the delicate vegetation, or from being torn up by the actions of overly enthusiastic mountain bikers or horseback riders. Groups of visitors led by park interpreters gain understanding of the special nature of the Garden of the Gods. Thanks to the master plan, millions more visitors will be able to enjoy the Garden of the Gods long into the future. (MSHC, Davis.)

DISCOVER THOUSANDS OF LOCAL HISTORY BOOKS FEATURING MILLIONS OF VINTAGE IMAGES

Arcadia Publishing, the leading local history publisher in the United States, is committed to making history accessible and meaningful through publishing books that celebrate and preserve the heritage of America's people and places.

Find more books like this at
www.arcadiapublishing.com

Search for your hometown history, your old stomping grounds, and even your favorite sports team.

Consistent with our mission to preserve history on a local level, this book was printed in South Carolina on American-made paper and manufactured entirely in the United States. Products carrying the accredited Forest Stewardship Council (FSC) label are printed on 100 percent FSC-certified paper.

MADE IN THE